The Art Of Robyn Denny

The Art Of Robyn Denny

David Alan Mellor

Architecture Art Design
Fashion History Photography
Theory and Things

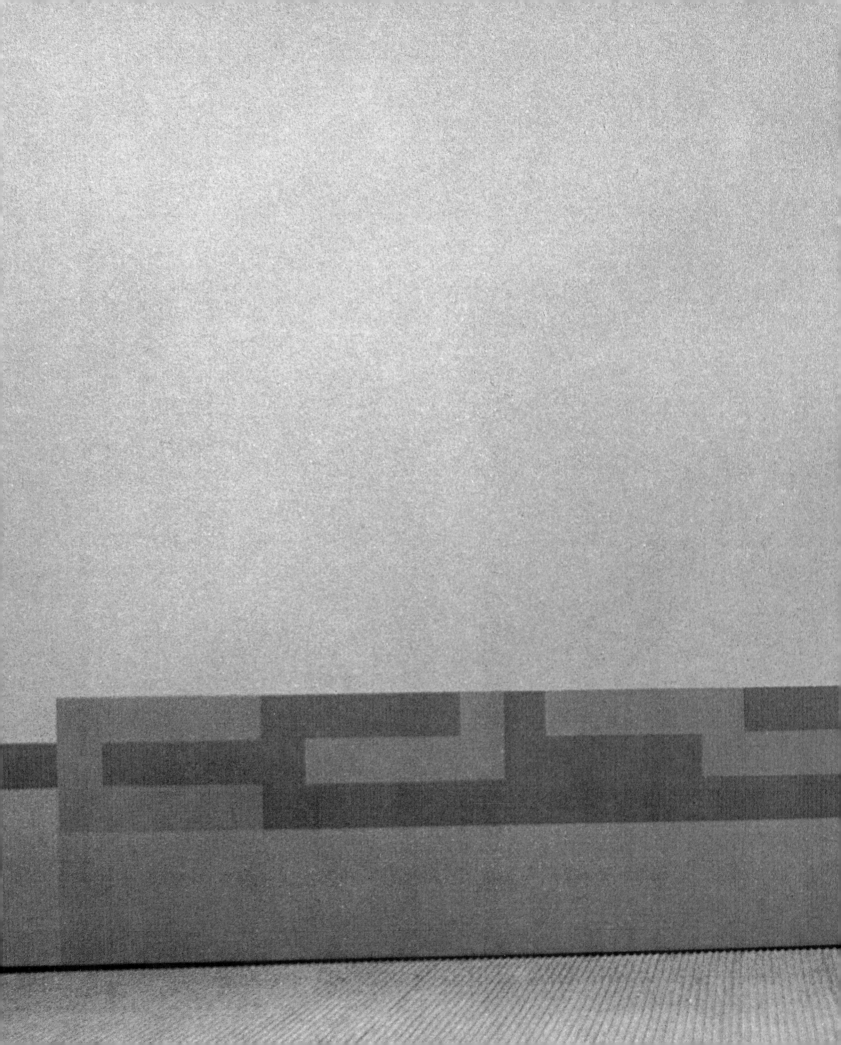

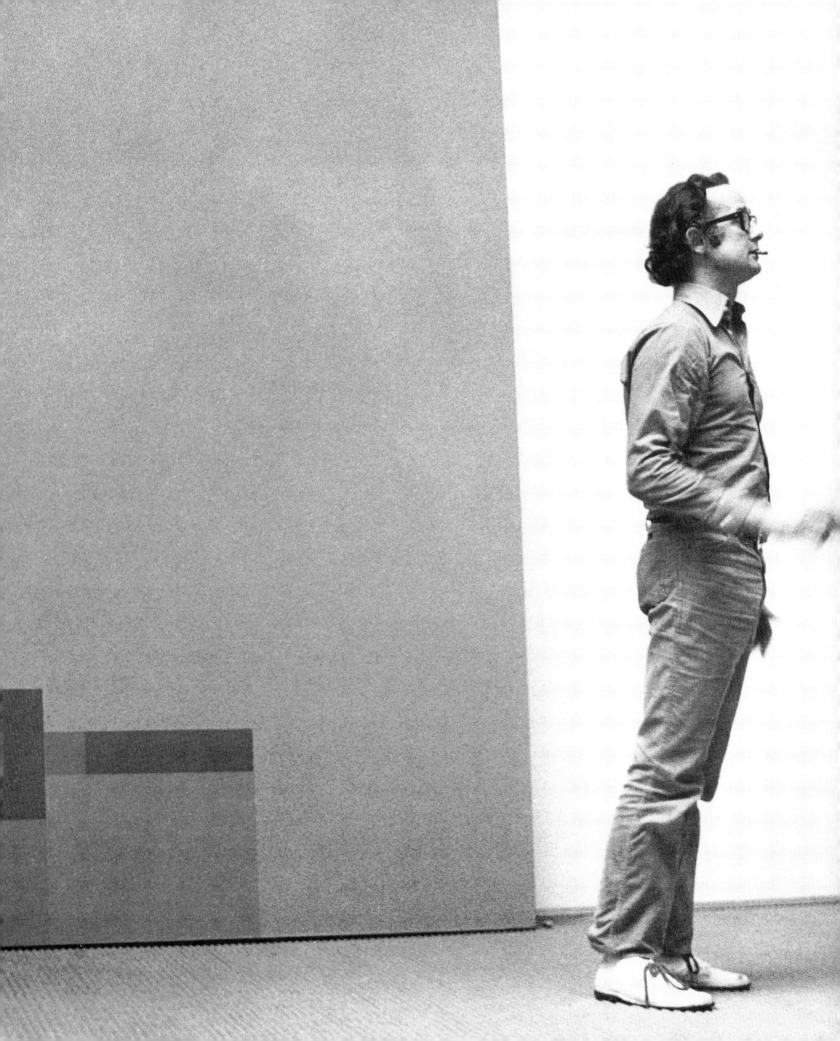

previous pages
Robyn Denny at the Kasmin
Gallery exhibition, London,
1971

Foreword

Looking at Robyn Denny's paintings is its own reward. The subtleties of surface and formal organisation unfold with time, with light, with mood. But his paintings have also, almost always, alluded to the physical world beyond the walls of formalist abstraction.

Denny's very early work sought to reconcile the pictorial language of art with his sense of mid-century urbanism. But these early paintings such as the *Red Beat* series soon gave way to more formalist environmental-scale abstractions which carried such titles as *Eckleberg* (a reference to F Scott Fitzgerald's *Great Gatsby*) and *Time of Day*. The scale, organisation and titles of those finely tuned orchestrations of line, colour and form of the 1960s and early to mid 70s, sought a meeting point between the fictive and physical realms.

In recent years this idea has reached a remarkable stage in its development. In such pictures as *Shadow Rising* and *Profile*, the eruption of physical matter into the middle of the monochrome sea of the picture plane is like consciousness bursting into the sublime. The longing to freefall into the gorgeous subtleties of delicately layered paint is arrested by the stubborn "plug of material", as David Alan Mellor so aptly calls it, sitting in the centre of our line of vision. Denny describes these objects not as rocks, though they look like them, but as forms, the 'rightness' of which emerged as he was working on them. These mysterious things, which appear weathered and old, radiate an aura of history and above all of time – the fourth dimension. Is *Shadow Rising,* then, a musing on mortality? Does the title refer to TS Eliot's "shadow rising at evening to meet you"? Perhaps. But with all Denny's work meanings are withheld, or rather the allusive richness of this threshold between two realms is such that the construction of meaning is always partially devolved to the subjectivity of the viewer.

Toby Treves, Curator, Tate

opposite
The Rosetta Stone,
from the title page of Robyn
Denny's Royal College of Art
thesis, **Language, Symbol,
Image** (detail), 1957.

To remember Denny's paintings – critically and analytically – entails looking at them across his unfamiliar paintings of the last 30 years: looking asquint to see them together within the framework of transformed Modernist abstraction. Familiarity with the paintings of Robyn Denny has tended to be limited to works of a single decade – from the late 50s to barely those of the early 70s – since, after his Tate Gallery retrospective exhibition in 1973, his paintings have been unacknowledged, secrets of a sort and out of time, in an art historical oblivion. This blank but dense zone of secrets is, perhaps, thematised by Denny in his most recent paintings, particularly in the spectral, lunar-lit, *The Secret Life of Art*, 1999-2002. Resembling a Biederman Structuralist relief which has been lost at the bottom of the sea and eroded to reveal some organic inner form, the painting falls under the colour of Symbolist melancholia.

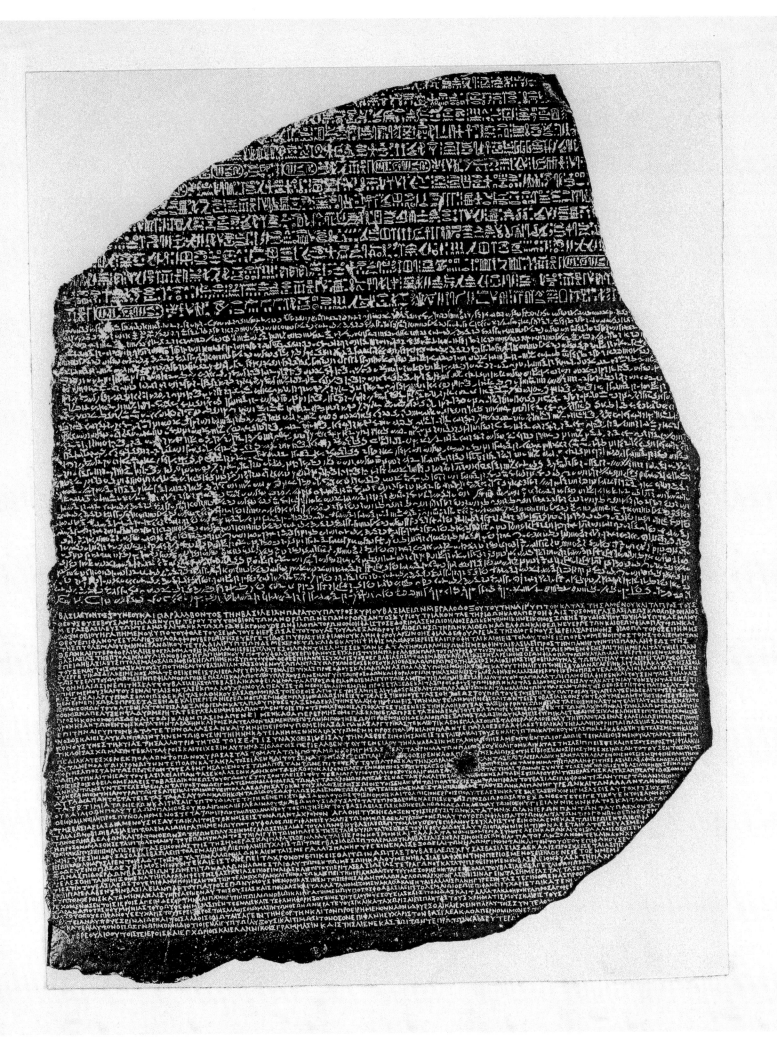

Secrets

1 & 2

Robyn Denny in conversation with the author, 12 July 2001.

3

Alloway, Lawrence, Introduction, *Robyn Denny*, London: Molton Gallery, 1961.

Perhaps the central narrative of Denny's art, since the late 70s, has been the ruin of formalism and also the ruin of a former classicising promise of perfection, one that presided over his ineffable paintings of the high 60s. So, since the late 70s, his paintings have remembered a prior idealism, while crudely dismantling their apparent symmetries.

The moment of this change in the late 70s was around two series: the large painting group, *Travelling* and – more importantly – the scarified, St Elmo's Fire world of the *Moonshine* drawings. *Travelling* seethed with crepitating rectilinear movements, growths which in the 80s would become a single white scribbled line. Denny has sensed some 'secret' here; a spatial denominator which exists between the paintings: a line, which links the only one he still owns, to the one secreted in the Tehran Museum.[1] Somehow the line acts, for Denny, as the soulful remainder, the secret sharer across the globe between the *Travelling* series which have been dispersed or lost: "… I know that between these points on the compass there is a secret line… [and] I've realised that the line will be the only thing that's left".[2] And that – pictorially – is what has happened. The lightning line which lights up the *Layline* series is at once a reduced form, from the great line elements of the 60s and 70s paintings, but it is also a flickering survivor announcing an advent and a loss – "… the only thing that's left" from the depleted phosphorescence of *Moonshine* and the thin border markings of *Travelling*.

On reflection, this topic of age and distress, of cultural memory and the decipherment of the always already disappearing inscription of line has actually had a long underlife in Denny's paintings. Perhaps the contemporary accolade for Denny as being an Apollonian abstractionist, in the 60s, was always only part of the story. As Lawrence Alloway remembered it, looking back from the vantage of his November 1961 introduction to the catalogue for Denny's Molton Gallery exhibition of big game-board canvases, such fading texts and vanishing lines were already part of Denny's formative years. Alloway raised Denny's deployment of writing and line as beginning for him in the 50s, raising the enigmas of the Rosetta Stone and signs of antique cultures folded into 50s beat lingo:

> In his early work Denny made great play with letters stencilled in paintings or pasted on collages. He was fascinated by the state of ancient inscriptions, which were clearly significative, but hard to decipher because of time. Either the language had been lost or the message partially effaced. Letters and words ('go', 'man-man', and 'one two one') were on a border of legibility….[3]

The Secret Life of Art
1999-2002
Acrylic and mixed-media
on board
88 ½ x 72 in
225 x 183 cm

Secrets

Eckleberg
1961
Oil on canvas
72 x 84 in
183 x 213.5 cm

opposite
Travelling
1976 - 1977
Oil and oil crayon on canvas
96 x 78 in
244 x 198 cm

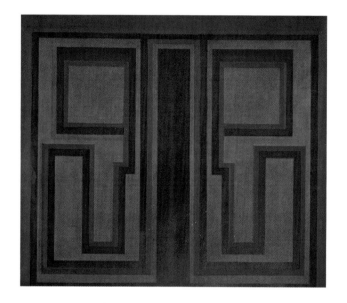

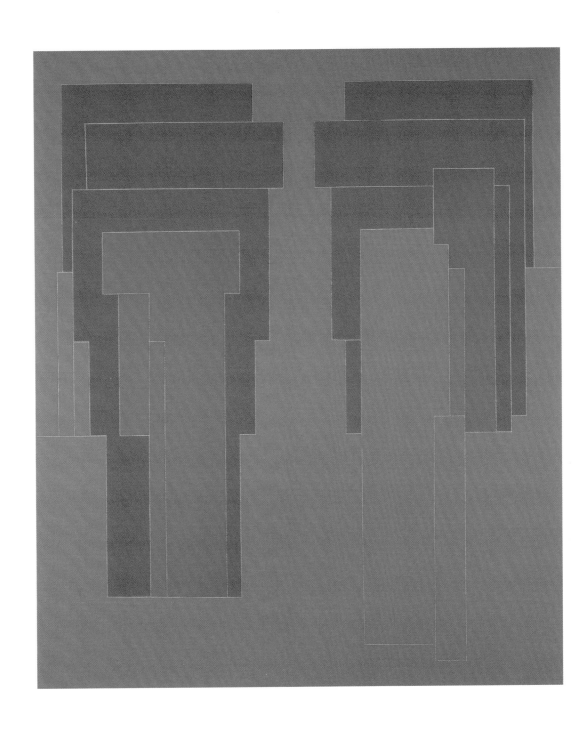

4
Fitzgerald, F Scott,
The Great Gatsby,
Harmondsworth: Penguin,
2000, p. 26.

5
Krell, David Farrell,
Intimations of Immortality,
Pennsylvania: Penn State
Press, 1991, pp. 44-46.

If in 1961 Alloway was looking back as well, looking past the novelties of the new formalist paradigms of Situation painting and Hard Edge – the styles with which Denny was supposed to be identified – he had succeeded in finding an alternative historical track – one which was faded and textual, yet still held the power of ambiguous declarations and cryptic disclosures. In the confrontation of the spectator with the absolute frontality of the paintings at the Molton Gallery, London, there was to be deciphered signs of tragic sight and loss. The geometrically encrypted brooding eyes of a fictional optician's sign, found in the wastelands in *The Great Gatsby*, were re-figured by Denny as the painting *Eckleberg*, 1961: "… above the grey land and spasms of bleak dust which drift endlessly over it, you perceive after a moment the eyes of Doctor TJ Eckleberg. The eyes of Dr TJ Eckleberg are blue and gigantic. Their retinas are one yard high. They look out of no face…."[4] The apparent vacancies of Hard Edge were awash with enigmas of reading, as if active in that existential confrontation of Ishmael gazing upon the brow of Moby Dick, which was represented by Melville as being like the philologist Champollion trying to decipher "the wrinkled, granite hieroglyphics…" of the Rosetta Stone.[5] Such a 'frontal ontology', becomes a form of confrontational decrypting, around the same historical instance and metaphor which Denny had used, the hieroglyphics of the Rosetta Stone, to which he gave prime place in his Royal College of Art thesis in 1957 and in 2002, refigured again, as a proxy of broken stone, in his painting relief, *Shadow Rising*. The primal, prehistoric markings on stone, and stone games – which were a topic of Brutalist sculpture and art in the 50s, with Turnbull and Paolozzi, for example – have been re-activated by Denny for the new century.

From **Layline** series
(series of 14)
1982
Acrylic and crayon on paper
30 x 22 in
76 x 56 cm

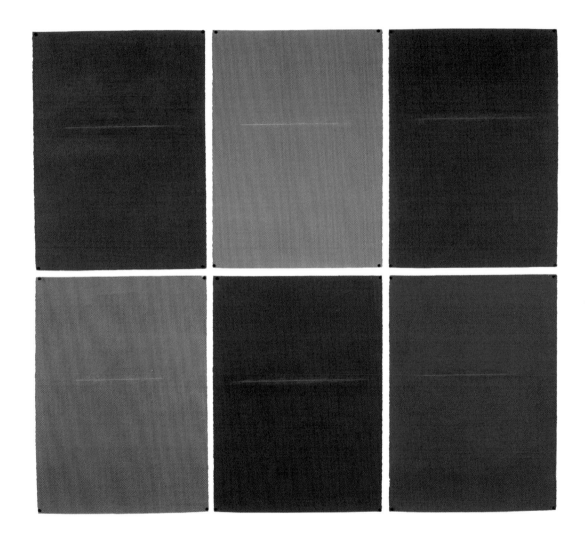

Secrets

From **Moonshine** series
(series of 16)
1977
Acrylic and crayon on paper
30 x 22 in
76 x 56 cm

opposite
From **Pepsi Tokyo** series
(series of 13)
1982
Acrylic on hand-made paper
30 x 22 in
76 x 56 cm

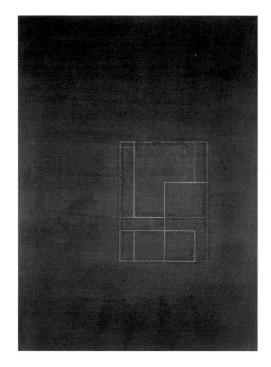

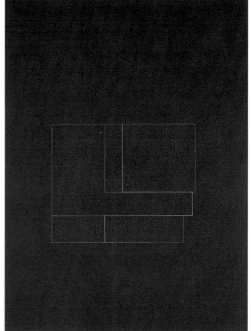

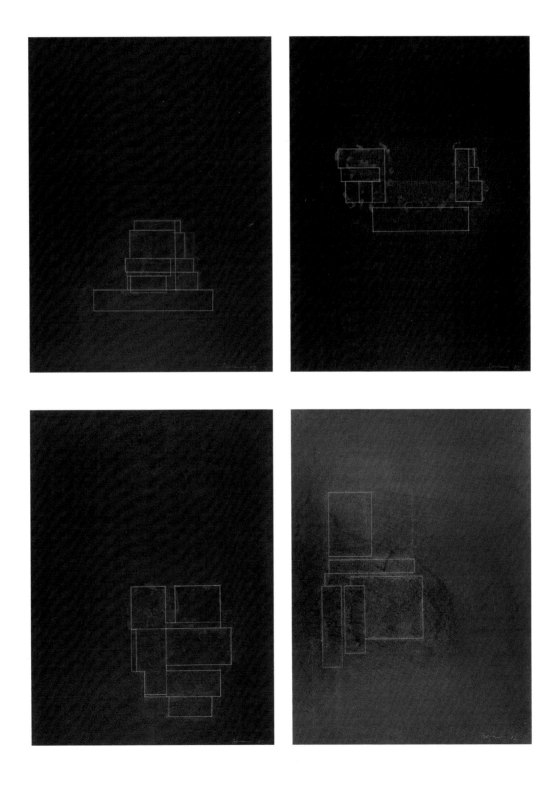

6

Deleuze, Gilles,
"An Unrecognised Precursor
to Heidegger: Alfred Jarry",
Essays Critical and Clinical,
"(T)hat which shows itself in
itself", London: Verso, 1998,
pp. 91-98.

7

Robyn Denny in
conversation with the
author, 19 July 2001.

Visual disclosures were made in 1961 – of unfolding, virtual spaces – and still, today, a form of (Heideggerian) self-disclosure, is operative in Denny's paintings which elevates them in terms of Modernist pictorial and scenic enquiry.[6] The head-on address of these paintings – especially in *Footlights 1* – becomes a gesture of opening, rather than the apocalyptic closing of Rothko's Seagram murals. Denny wishes his paintings to be "convincing as entities with the capacity of revealing aspects of themselves continuously, as if they were laying down a marker for the future".[7] This suggests a process of a self-disclosing painting connecting with the unfolding, developmental acts of human perception. And that perceiving body is also implicated and brought inside the painting as a line – as a lively abstracted contoured trace – something which surfaces in recent paintings such as *Profile*: a freely transcribed version of the profile's edge configuring Rembrandt's *A Young Woman in Profile with a Fan*, 1632. *Footlights 1*, 1999-2002, embodies that notion of facial traces, but in this case placed on artefactual self-display in the ashen grey-blue of the irregular inset rectangle which seems stretched like the cloth of Veronica. This carries no imprint of Christ's face, but instead a head-on-hand-like white painted eruption which started to defy gravity and piled up, like rock, on the vertical surfaces of his paintings of the last year.

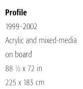

Profile
1999-2002
Acrylic and mixed-media
on board
88 ½ x 72 in
225 x 183 cm

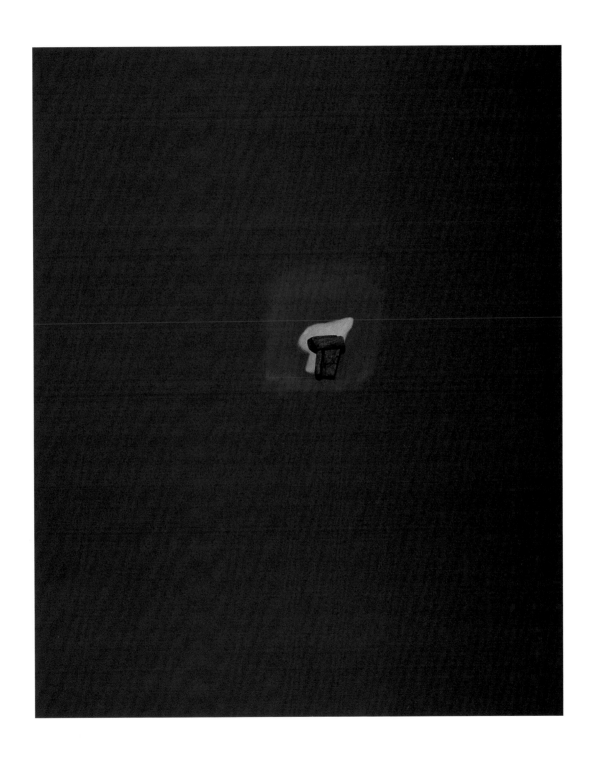

8
Roland Barthes, cited
by Foster, Hal, *The Return
of the Real*, Cambridge, MA:
The MIT Press, 1996,
pp. 133-134.

9
Foster,
The Return of the Real,
p. 134.

10
Foster,
The Return of the Real,
pp. 140-141, (Foster's italics).

11
Foster,
The Return of the Real,
p. 149.

Is this shock of a rent in the surface and the bursting out of a real presence – the intrusive physicalities of these outcrops in the midst of the beautiful monochrome – a replay of 50s Brutalism, of Fontana's materialist disruptions – or does it correspond to the rise of that aesthetic of the Sublime of the 80s and after; that which Hal Foster has dubbed, "The Return of the Real"? Foster's 'Real' was based on Jacques Lacan's definition, of a traumatic encounter which was screened, but which erupts its way to the surface like the Barthesian concept of the *punctum*: "It is this element which rises from the scene…. It is acute yet muffled, it cries out in silence. Odd contradiction: a floating flash'."[8] In Denny's paintings of the last two decades the centred crevices, the rents and the scarlet tears have appeared as traumatic points, as 'floating flashes', where "… we almost seem to touch the real".[9] The weird presence of the gleaming, self announcing, apparently raw, enigmatic, rock and the anamorphic plays of shadowing and presence in, say, *Profile* or *Shadow Rising*, emanate from the centre of the painting to address the spectator, as a point of light, as a gaze, just as the hallucinatory eye-glasses of *Eckleberg* had functioned in 1961.

Foster distinguished areas of contemporary art where this emanating, threatening gaze from within the picture could be said to retain an uncanny agency: *"It is as if this art wanted the gaze to shine, the object to stand, the real to exist, in all the glory (or horror) of its pulsatile desire, or at least to evoke this sublime condition. To this end it moves not only to attack the image but to tear at the screen, or to suggest that it is already torn".*[10] The scratches and tears at the image which had first appeared in Denny's art in 1977, with *Moonshine*, intensified in 1982 with *Layline* and the *Pepsi Tokyo* drawings of the same year. They only go on conspicuous display – converted into raised islands which disrupt the pictorial field – from the close of the 80s. Denny's post 1989 art never moves towards that blurring of figure/ground boundaries and abjection which mark Bataille's idea of the *informe*.[11] This is probably because there is in Denny always a ramified and extensive screen, a frame, a stage to contain and show – to display – the unformed and raw; which could then contain the tears, stains, flows and lumps with which he anointed them after the final state of *Oh! Quel Culture* (completed in 1989).

Oh! Quel Culture

1982-1989

Acrylic on canvas

96 x 78 in

244 x 198 cm

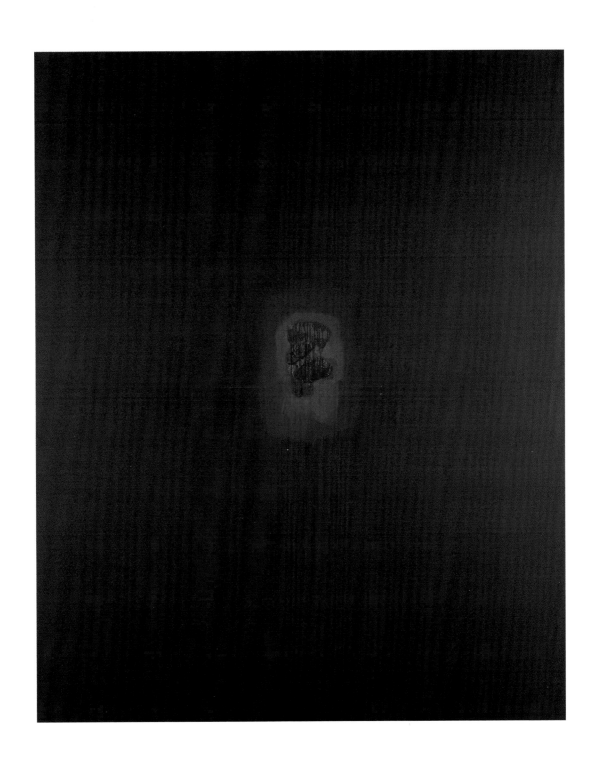

Shadow Rising

1999-2002
Acrylic, plaka and
mixed-media on board
88 ½ x 72 in
225 x 183 cm

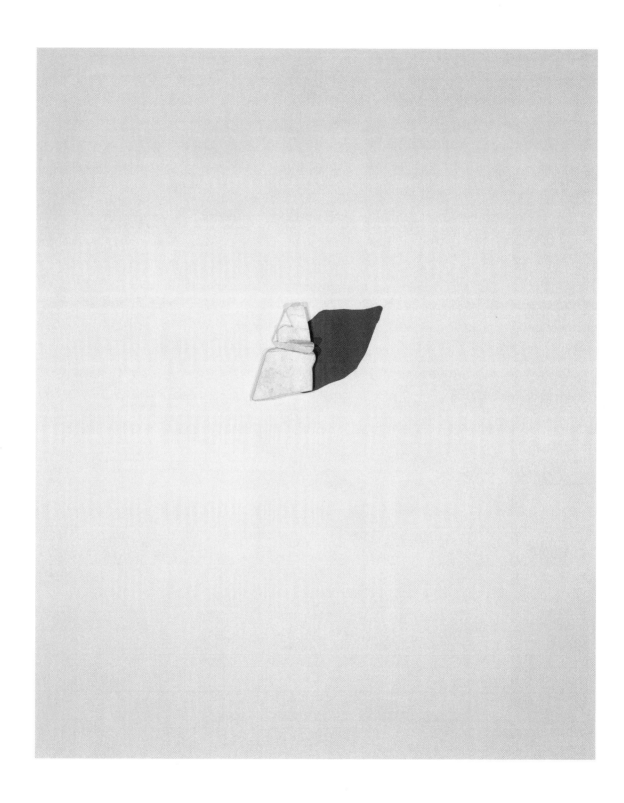

Secrets

12
Robyn Denny in
conversation with the
author, 19 July 2001.

In all this play of uncanny pictorial gazes and profane eruptions there are still the dialectics of scenography (and with his most recent work, *skiagraphia* – the writing of shadows). Looking at the Los Angeles paintings of the 80s, Denny has connected them with his earlier formal narratives: there is still the threshold line, the arch manipulations of aerial perspective by dissolving blobs of light and colour, and the recession of tones. Here was the retention of an "aspect of the theatre – proscenium, flats and footlights".[12] And in his most recent work, the memories of the pictorialised theatre – pictorialised by Sickert – move back to an elementary kind of illuminated space and substance, in *Footlights 1* and *Footlights 2*. This citation of the scenic mechanics of footlights, propels these new paintings towards the unregulated grotesquerie of the morphology of shadows – the *skiagraphic* realm. So a heterodox shadow springs out from *Shadow Rising*, as a purple puddle; and in *Footlights 2*, it is played out in reverse, as a light shadow.

13

Eliot, T S, *The Wasteland*,
London: Faber and Faber,
1940 (1999), pp. 23 - 24.

14

"As a child I had the habit,
when leaving a place that I
liked, of leaving there
something of myself. A coin,
a piece of paper, something
from my pocket concealed
where no one else would
find it. A crack in a wall, a
hole in a tree, or buried in
a tin. I can remember the
places now, and going back,
if they were still there, could
find them without difficulty.
The present and the future
blended in my mind for a
moment in that act – the
space between a kind of
sculpture out of time. For
me, in art, each work has
some meaning of that order
too. Each piece a mark in
space, a moment preserved,
a thought enclosed in time.
Thus whatever their function
as separate things, wherever
they are located in this time
or another, their role is only
properly realised if the
psychic link between them
remains intact. For that is
where the art lies, not in the
things themselves."
Robyn Denny
From the Townsend
Memorial Lecture at
University College London,
27 November 1974.

By incorporating the slanting projected shadows as areas of light, Denny has re-introduced an obliqueness – an anamorphosis – into the whole field of representation as an excessive counter-representation, like the snaking, disruptive lines of the *XSS* series in 1964 and a squinted revelation of pictorial secrets was performed. Nearly 40 years later Denny revisited some of his anamorphic preoccupations of the 60s, such as the diagonalised and twisted forms and limbs of *Secrets*, 1964. By titling his white-grounded anamorphic projection paintings, *Shadow Rising* and *Shadow Striding*, Denny extended his purchase on a discourse of ruined signs and the cultural uncanny. He has joined hands, metaphorically, with de Chirico's metaphysical spaces projected by shadow, and those of Dali, too; as well as Bacon's Van Gogh shadows. He has accomplished this by citing the shadows and their meaning from "The Burial of the Dead" section of T S Eliot's *The Wasteland*, that paradigm text of Anglo-American Modernist pessimism. *Shadow Rising*, with its purple cast shadow, already has links with line 25 of Eliot's poem and the optical presences around the red rock: "There is shadow under this red rock, / (Come in under the shadow of this red rock), / And I will show you something different from either / Your shadow at morning striding behind you / Or your shadow at evening rising to meet you; / I will show you fear in a handful of dust."[13] This is the realm of the secrets of the accosting sphinx viewed in frontal confrontation, of dematerialising encrypted words and erratic, intrusive, mineralised remains.[14]

Shadow Striding

1999 - 2002
Acrylic, plaka and
mixed-media on board
88 ½ x 72 in
225 x 183 cm

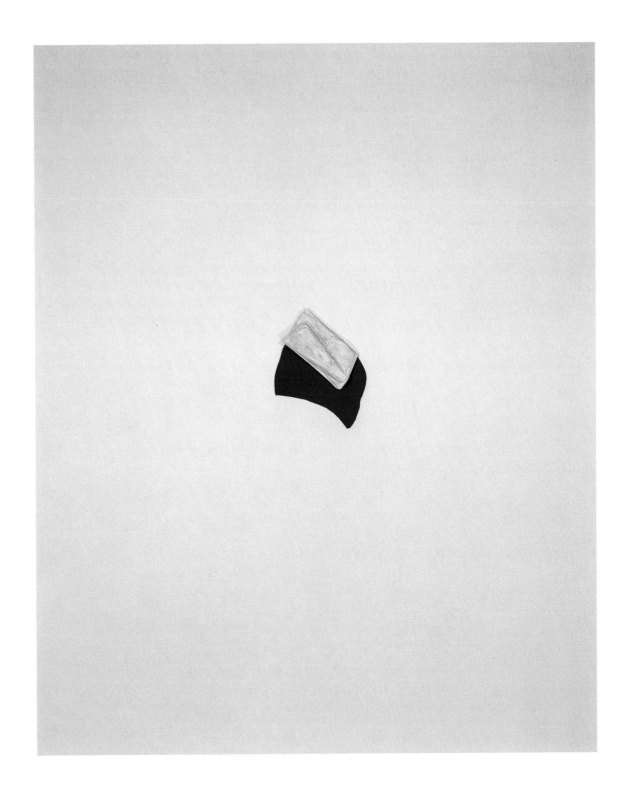

1
The exhibition was at Gallery
One, London, in January
1958, "British Painters and
Some of their Experiments",
The Times, 16 January 1958,
Robyn Denny Archive,
London.

opposite
**London Transport –
Embankment Station**
1985
Vitreous enamel
panels on all platforms
and intersections.
Arup Associates,
commissioning architects.

Outcrops butt out from the centre of Robyn Denny's painting-reliefs of 1999-2002, they stand out as a mix of stressed absorptive centre and extrinsic projective thing, even when veiled by a layer of paint, they indicate broken integrities and broken spatial (or sculptural) borders. Denny binds pitted, broken slabs to the whole of the canvas, often by colouring it in relation to the ground hue. But under the artificial paradise of colour there is a *maniera rustica* in his morphology – some passage of ruin has ordered them, and Denny readily sees the operations of time and distress working out a narrative of entropy. This relief rising up from the planar surface – the stone, the incised carving – that marks Denny's recent paintings, such as *Footlights 1*, *Profile*, *Shadows Rising* and *Shadow Striding* – has a tangential relation to the theories of Adrian Stokes, as well as being fossils of his mosaic works of 1957, where the tesserae were "now scattered brokenly about the composition… piled haphazardly in little mounds".[1]

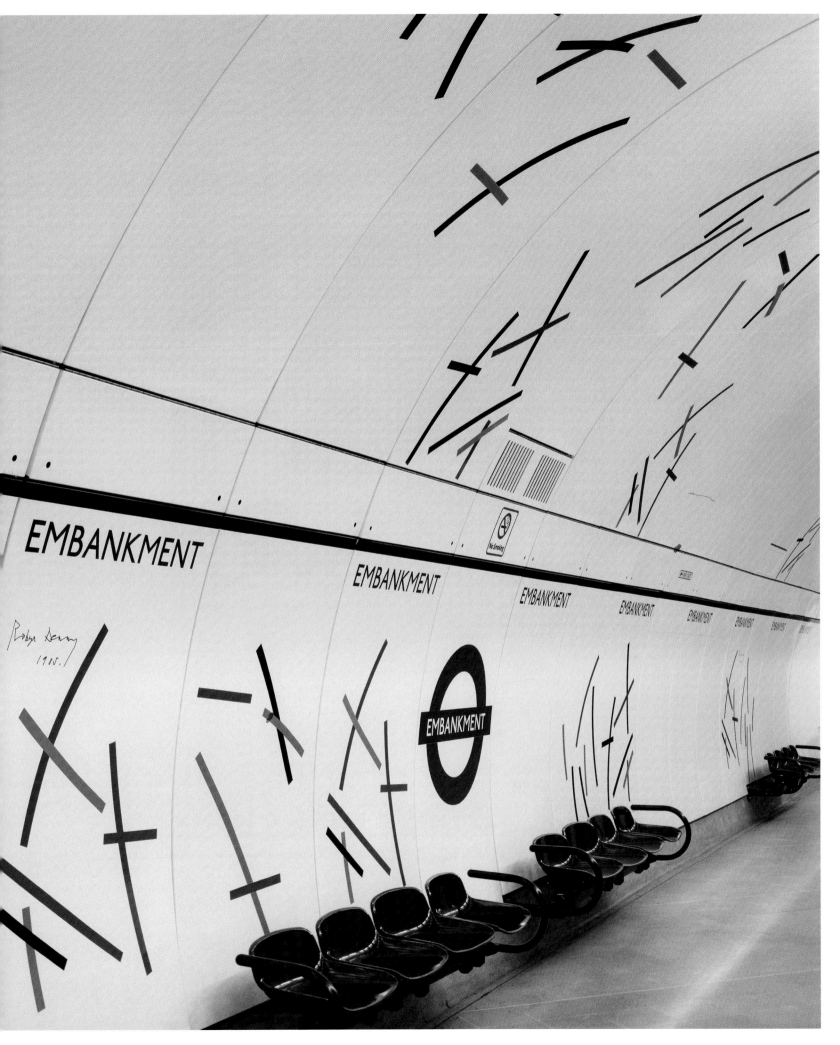

Glory in the Air
1985 - 1999
Acrylic on canvas
96 x 78 in
244 x 198 cm

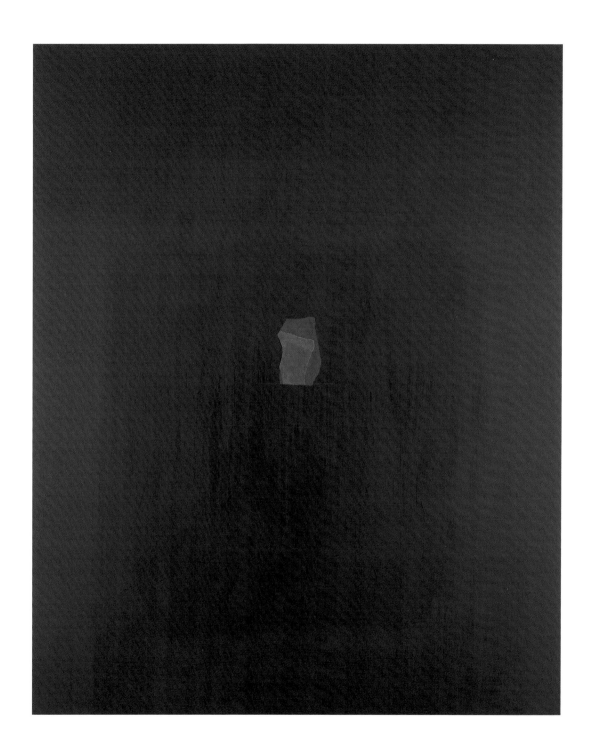

Monuments

2
Robyn Denny in
conversation with the
author, 26 July 2001.

3
Stokes, Adrian,
"Carving and Modelling",
The Image in Form,
Richard Wollheim,
ed., Harmondsworth:
Penguin, 1972,
pp. 47 & 48.

4
Stokes,
"Carving and Modelling".

5
Robyn Denny in
conversation with the
author, 26 July 2001.

above
Plaster Painting
1956
Plaster of Paris on board
17 x 15 in
43 x 38 cm

below
Mosaic (B)
1955 - 1956
Mosaic and mixed-media
on board
19 x 17 ½ in
48 x 44.5 cm

Adrian Stokes visited Robyn Denny in July 1972 and talked with him about the passage of time and traces that were left in the process of representation.[2] Stokes spoke and wrote of the clarity and self-disclosing aspect of a certain kind of carving strategy, and one that had applications to painting. He prioritised a form of mark making which was: "An augmentation on the surface. A rose facing outward from the stem. A face, the outward part, the augmentation of all that is within the head. A true painting is of such a kind: an augmentation upon the surface of wall or canvas."[3] But Stokes was not simply arguing for form; there was a temporal dimension, as well, and one which Denny had been interested in since the mid 50s and which his mosaic works were part of. From the vantage of his painting-reliefs of 1999-2002, it is now more obvious that this form of inscribed memory has long been central to Denny's project as an artist: in Stokes' words "Thus is time recorded in space: an augmentation upon the surface. The visual world is an accumulation of time apprehended instantaneously."[4] And this is what these latest paintings are, weathered and deep accounts of longevity and feeling. In Denny's own words: "Bits that are left after an eternity of weathering."[5]

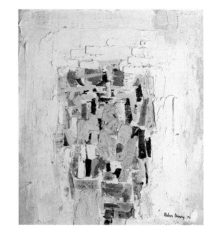

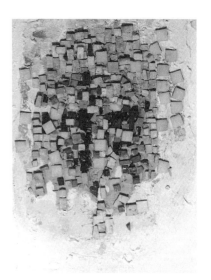

5-10
Robyn Denny in
conversation with the
author, 26 July 2001.

Ark 24
The "Day-Glo" issue,
Roddy Maude-Roxby ed.,
London: Royal College of
Art, 1959.

Since the turning point of the *Moonshine* and *Pepsi Tokyo* series, the sense of patina, of weathering, from continual overworking has been crucial to Denny, as a point of access to the past, to memory and the 'deep life' – "Detritus is what you find there".[6] With these worn surfaces, like that of a scarred Lucio Fontana *Spatial Concept*, Denny is conscious of what he calls the *"Stones of Rimini* effect, of activating a surface".[7] So his practice is embedded in the past of Modernism; and before – the simulation he effects, by which his carved and painted centres become stone-like, has an equivalence to the illusionism of Baroque sculptures where "marble looked like velvet".[8] Alongside this artifice, though, is a wished for primitivism, so that the relief elements are "not natural items but constructed, like in archaeology".[9] Denny has recalled a visit he made with Howard Hodgkin to Crete in the mid 60s. On a walk one day near the Palace of Phaestos, he found the lower half of a small Cycladic figure washed down from caves above; a votive offering, a "little piece with meanings".[10] His expressed modesty of aim is like Ezra Pound and T E Hulme's bid, at the time of the foundation of British Modernism, for a theory of the image as small, hard and condensed.

Coca Tokyo
1982 - 1988
Acrylic on canvas
96 x 78 in
244 x 198 cm

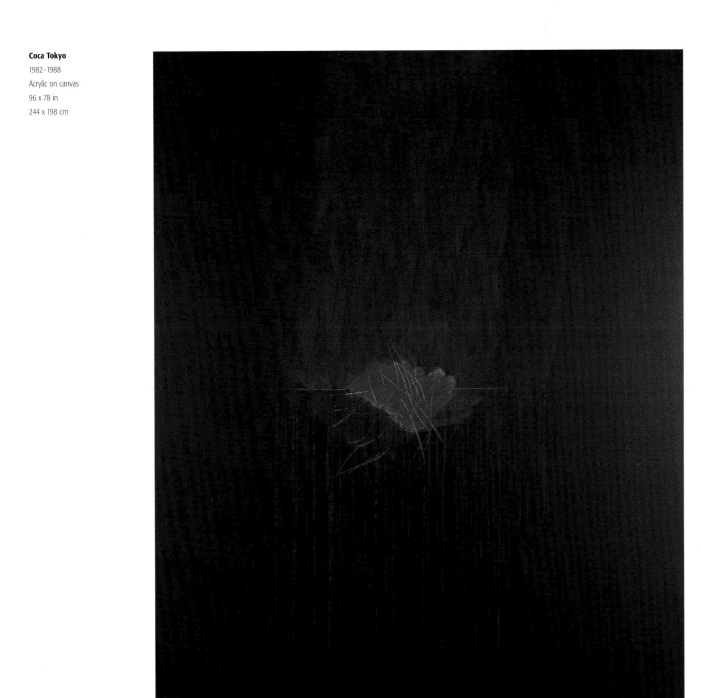

11

Robyn Denny in
conversation with the
author, 26 July 2001.

There is an agenda of compacted Modernist monumentalism which extends into
Denny's art and which reaches a peak in his high 60s abstractions. In 1954 Denny saw
Sickert's painting *Sir Thomas Beecham Conducting*, 1938, in Richard Buckle's *Diaghilev*
exhibition at the Royal Academy. He was impressed by the way in which "… the figure
loomed up from the bottom of the painting".[11] Denny read the Sickert against the grain
and consensus of contemporary Kitchen Sink painting, in terms of a more abstract
language of painting. For example, the formalised bilateral human body – vital to his high
60s abstracts such as *Ted Bentley*, *Gully Foyle*, *Folded* or *Overreach* – is diagrammatised
here, with Beecham's arms symmetric and his body a silhouette. Similarly, Denny's
shorthand memory of this magisterial painting – now in the Museum of Modern Art,
New York – has a kind of suggestiveness in the light of his own placing of canvases close
to the floor from about 1960, letting the monumental shapes rise up from the ground.

Sickert's spatial platforms were, literally, representations of the stage of performance,
and in Sickert's and Denny's threshold scaffolds there is the presentation of representation
in performance. They compose visual figures embodying the presentness, the self-
disclosure of presentation and representation. *Footlights 1* and *2* abstractly transcribes
aspects of at least two of Sickert's paintings of performers, with their hidden or low
thresholds of the theatrical stage: *The Lion Comique*, with its deployment of flats and
staging levels and borderings, and *Sir Thomas Beecham*. The stiff front of Beecham's
dress shirt fascinated Denny and it has survived as a living formal fossil in the white
shape in *Footlights 2*. By tracing the shadow projected upwards from imagined footlights
below and in front of *Footlights 2*, Denny achieved something of the anamorphic shape
and appearance generated by the underlighting across the face of *The Lion Comique*.
With the asymmetric paintings of 1964-1965, he dedicated himself to the underlife of
forms and with *Footlights 2*, to the underlighting of bodies, indications of secrets beneath.

Footlights 2

1999 - 2002
Acrylic, plaka and
mixed-media on board
88 ½ in x 72 in
225 x 183 cm

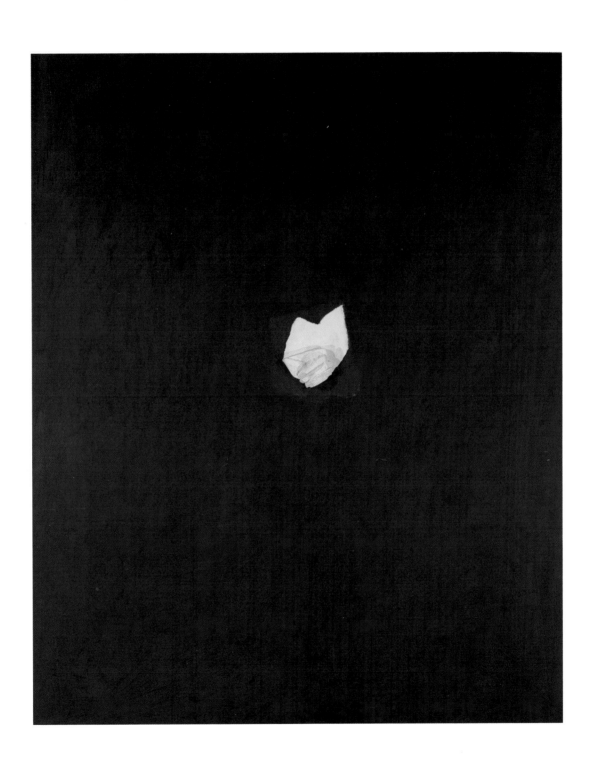

Monuments

Indiana Red
1985 - 1986
Acrylic on canvas
96 x 78 in
244 x 198 cm

opposite
Gothic-A-Go-Go
1985 - 1986
Acrylic on canvas
96 x 78 in
244 x 198 cm

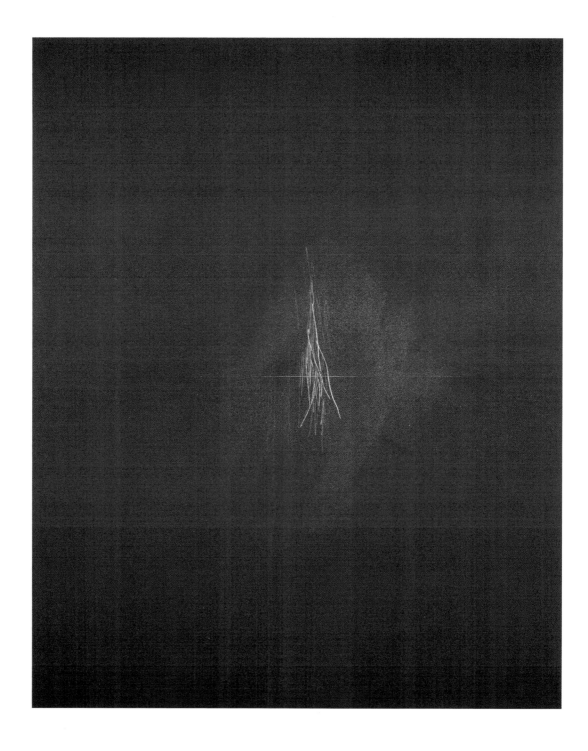

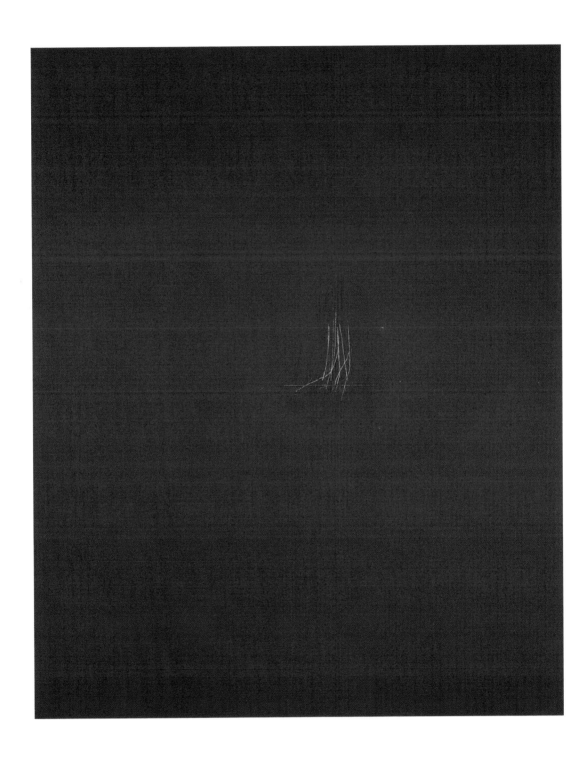

12

Bann, Stephen,
"The Framing of Material",
*The Rhetoric of the
Frame*, Paul Duro ed.,
Cambridge: Cambridge
University Press, 1996,
pp. 136-152.

13

Stammelman, Richard,
"Afterword Image, Color,
Light: The Lure and Truth
of Painting and Poetry",
Yves Bonnefoy, *The Lure
and Truth of Painting*,
Chicago: University of
Chicago Press, 1995,
pp. 189-215 (pp. 194-195).

Denny's monuments contain structured forms which act as countervailing forces within the whole field of the painting; 'absorptive centres' of materiality, to use Michael Fried's term.[12] In his post 1991 paintings, the battered, irregular constructed centres suggest an oppositional force on account of their contrived brute materiality of scars and phantasmic geological histories; they have entered into a new spatial dialectic, a new tension in relation to the monochromatic field upon which they find themselves located. A kind of coruscating, pitiless pitting builds a core, a plug of material which rises over the landscape, in the form of a relief plateau. This materiality then engages with the colour ground in a chameleon fashion. No longer that evanescent, featureless, dematerialised slab of the high 60s, but a cracked, fissured and refractory thing, while still carrying forward some measure of that former ineffability, that effect of a disembodied rose garden, especially in the turbulent colour perfumes of paintings such as *Coca Tokyo* and *Glory in the Air*. Writing on Yves Bonnefoy's aesthetics, Richard Stammelman has underlined this re-marking of the beautiful surface: "The artist's responsibility [is]… to endow the image with signs of temporality and finitude, marking its surface with cracks and fissures and other such imperfections and errors: 'The purest form is always the one / Pierced by the mist which fades away / Trampled snow is the only rose /.'"[13] This process of re-inscribing materiality and a poetic ruination has its analogue in Denny's astringent polychrome clouds and the scratchy *griffes*, from his Los Angeles years, which are placed so centrally for our gaze.

Those scratches are present in *Indiana Red*, 1985-1986, *Facing North*, 1984-1989, (first shown at Hirschl Contemporary Art, London in 2001), and in *Gothic-A-Go-Go*, 1985-1986. It can be argued that a strand of Californian Gothic, a sub-genre of that revived Gothic of the 1980s and 90s, was active in the paintings which Denny made in Los Angeles and afterwards: in their bereft Romanticism, in their lurid melodramatics and atmospherics, and in their evidence of energetic scarifications. In contemporary New York, those Neo-Expressionist scratchings and fracturings were reduced to a simulated inarticulacy, but in Denny's painting, whose title advertises this Gothic idiom, *Gothic-A-Go-Go* , he isolates and exhibits the expressionist gesture, (just as he had warily framed it and contained it in *Home from Home* in 1959), by putting the scratches on his flat 2D shelf horizontal line where they are the object of an ambivalent regard for authentic expressionist traces. They are displayed as a language form, a coded gesture – however energetic – against a sensational red.

14
Edmundson, Mark,
*Nightmare on Main Street
Angels, Sadomasochism
and the Culture of the
Gothic,* Harvard: Harvard
University Press, 1997,
pp. 51-56.

15
Edmundson,
Nightmare on Main Street,
p. 113.

And in his titling, as in his titling of the late 50s, there is the animation of a certain pop music, choreography and a certain cultural ambience. The cultural historian Mark Edmundson has identified that exemplary figure who, in the mid 80s *Nightmare on Elm Street* films, emerged to staff the contemporary Gothic: Freddie Kruger, who figures as a slasher with an intense intelligence.[14] Edmundson has seen the contemporary Gothic as a bid to further engage with the cultural promises of transcendence in a harsh, terrorising manner. Contemporary Gothic, Edmundson asserts, is a move away from the promises – which propelled high Modernist art and architecture – of transparency, quoting Greenberg's rationalised activated, total design canvas, from his essay, "Our Period Style".[15] Such a Modernism obliterated or repressed metaphysical content, and therefore the realm of memory and of the unconscious. The failure of Modernism in the 60s – and here we would nominate Denny as one of its most uncompromising advocates in Britain – is brought forward by Edmundson as a dynamic in the resurgence of a Gothic sensibility. What first occurred in the late 70s and then went on to become a cultural tumult in the 80s, was a return of the content which had been repressed by Modernism, as much for Denny as for other artists. (But then perhaps, Denny's Modernism, even in the 50s, had always had a slightly haunted feel: haunted by the palimpsest implications of gesture, excess and detritus and by some absented metaphysical void in his high 60s temple and altar spaces.)

Monuments

Facing North
1984-1989
Acrylic on canvas
96 x 78 in
244 x 198 cm

opposite
Over Here, Over There
1982-1983
Acrylic on canvas
96 x 78 in
244 x 198 cm

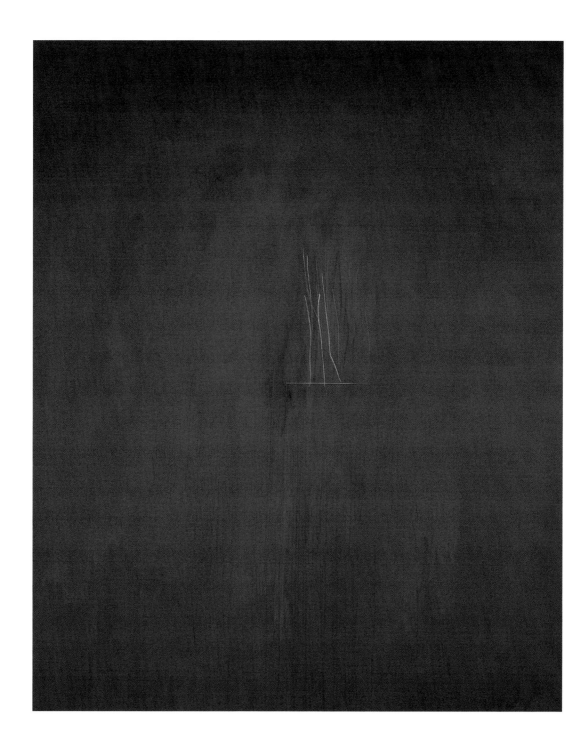

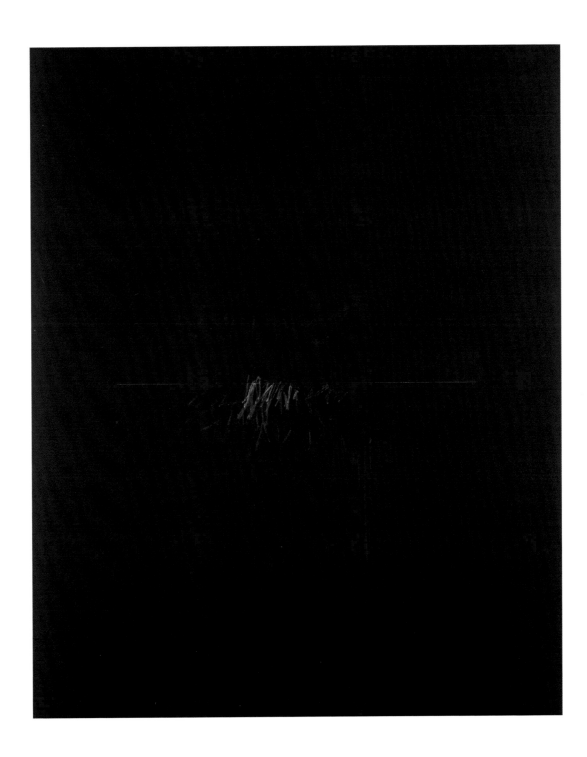

Monuments

16
Robyn Denny, text for
Drawing Show exhibition,
Bernard Jacobson Gallery,
London, 1996.

Now the tesserae and isolate mounds and scratches returned, and the ghostly *Will o'the Wisps* and the secret passages and shining entities that are lodged in Denny's canvases of the 1980s and 90s, in the deepest grounds of dark blue and scarlet oblivion, with only the occasional tenuous, drawn line, rather than the fully deployed mechanisms of a right-angled, geometricised, abstract scenography with which to carry scepticism and rationalisation. The same more formalised bundles of lines with which Denny had made orderly and lyrical polychrome staves for his 80s London Underground project, had an inverted contemporary life in *Gothic-A-Go-Go*, where they ran ragged, clawed, and unregulated.

When he came to reflect on the identity of his scratched drawings which he made in 1982, Denny conjured up the picture surface as scarified tissue, the dermis of a phantasmal body: one capable of bearing the weight and vicissitudes of human experience, metaphorising pictorial trauma and scars and jubilation. In a statement which he wrote acting as an *apologia* for the *Pepsi Tokyo* series, Denny insisted upon a new corporeal identity given to his paintings and drawings:

> These drawings were made over a period of six months at my studio in
> Los Angeles in 1982. During the period 1974 to 1984 I made many works
> on paper. They are tactile, physical, their image and identity lost and retrieved,
> detritus and renewal embodied like a palimpsest in slow motion over a long
> period. Like the sweet things in life they stand for loss and gain and renewal.
> Everything I have done since stems from them, hence they represent a kind
> of landmark and turning point for me.[16]

Looking and Thinking

1982 - 1983

Acrylic on canvas

96 x 78 in

244 x 198 cm

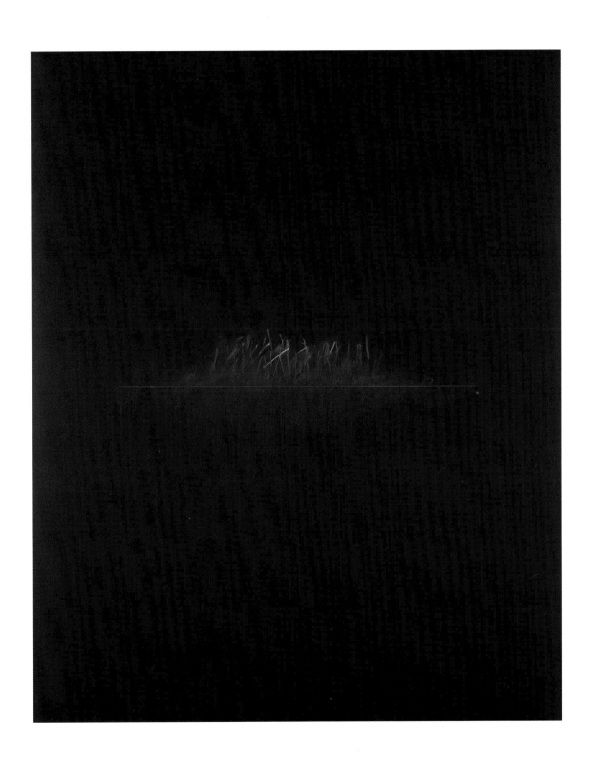

A Sense of Occasion

1982 - 1983

Acrylic on canvas

96 x 78 in

244 x 198 cm

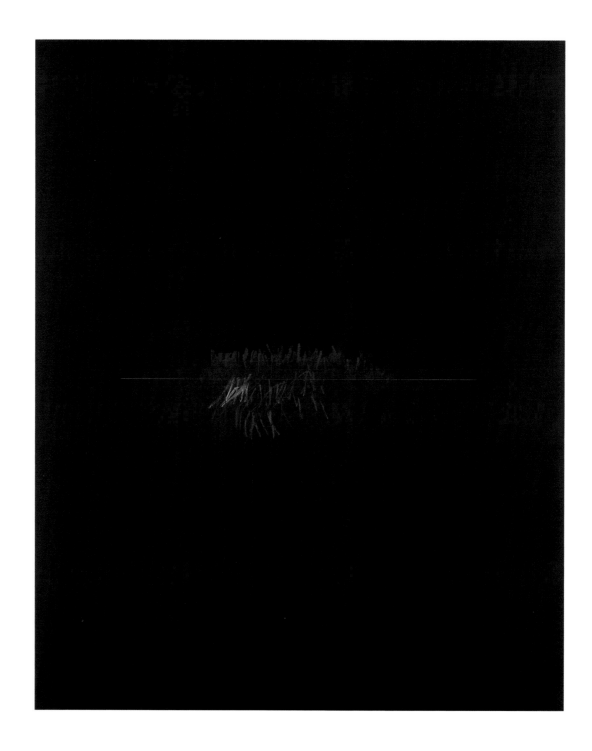

Monuments

17
Derrida, Jacques,
The Truth in Painting,
Chicago: University of
Chicago, 1987, p. 52.

18-20
Robyn Denny in
conversation with the
author, 12 July 2001.

21
Bordo, Jonathan,
"The Witness in the
Errings of Contemporary
Art", *The Rhetoric of the
Frame,* Paul Duro ed.,
Cambridge: Cambridge
University Press, 1996,
pp. 178-202.

22
Robyn Denny in
conversation with the
author, 12 July 2001.

This bravura drawing series, *Pepsi Tokyo*, together with *Moonshine* of six years before, marked what Derrida calls the *brisure*, the hinge, for Denny, in the sense of a breaking and a joining of another moment in his career.[17] The surfaces of *Moonshine* and *Pepsi Tokyo* were the sites of formal strife. The bare, spare, battered, single line carried significations which had been previously located in evenly realised plaques and planar rectangles: now he was "not filling them in, it was just the line".[18] An act of erasure as well as deposit was occurring in these works, as they "were washed, re-drawn and sanded down".[19] Denny described the transformation, the paradigm shift in his art, towards a new subjectivity, between 1977 and 1989, as being in reaction to it "becoming very dry".[20] His severe style of colour slabs, which had held sway from 1961 to 1977, had created a kind of niche for the viewer's sense of their own physical identity, with undertones of the pale, mute crypt – a place of potential transcendence.[21] Somehow his own body, or perhaps the phantasmal skin formed by the heavily worked surfaces, was being scoured, undergoing a process of abrasion, moistening and aeration, to transcend frailty and restore that which he feared absent from his work of the later 70s, eventually producing: "… an art that was physical, demanding, sensuous… [transforming] aspects of myself that were getting cauterised and lost".[22]

1

A summary of Merleau
Ponty's arguments can be
found in Johnson, Galen A,
"Ontology and Painting: Eye
and Mind", *The Merleau
Ponty Aesthetics Reader*,
Galen A Johnson ed.,
Evanston, IL: Northwestern
University, 1993, pp. 35-55.

2

Irving Sandler typescript
"Robyn Denny, interviewed
by Irving Sandler, London,
Summer 1961", Robyn
Denny Archive, London.

opposite
Fashion shoot with
Sue Lloyd at the Molton
Gallery, London, for *Queen*
magazine, 1962.

For eight years, between 1961 and 1969, Robyn Denny painted what are arguably some of the most accomplished abstract paintings made in Britain in the twentieth century. They are grave and gracious – (and also sometimes capricious) – objects which, among other things, invite the spectator into an extraordinary space of projected bodily presence: they are exemplary versions of what Maurice Merleau-Ponty designated a "lived perspective" in his contemporary writings.[1] The paintings of 1961 to 1969 are generally secular and carnal in their address, differing from the recent accosting invitation in *Shadow Striding*, to place the body in a (secretive) elemental environment, encompassed by the possibility of a space possessing the prospect of metaphysical revelation. (As with the Rothko's he saw at the 1958 Venice Bienalle, and Tintoretto's transubstantiating decorations for the Scuola di San Rocco.) Carnality and potentiality for bodily movement and action was crucial to Denny's agenda of the 60s: as he had told Irving Sandler, in 1961, his wish, with his deployment of large painting, was "to create a physical sensation".[2]

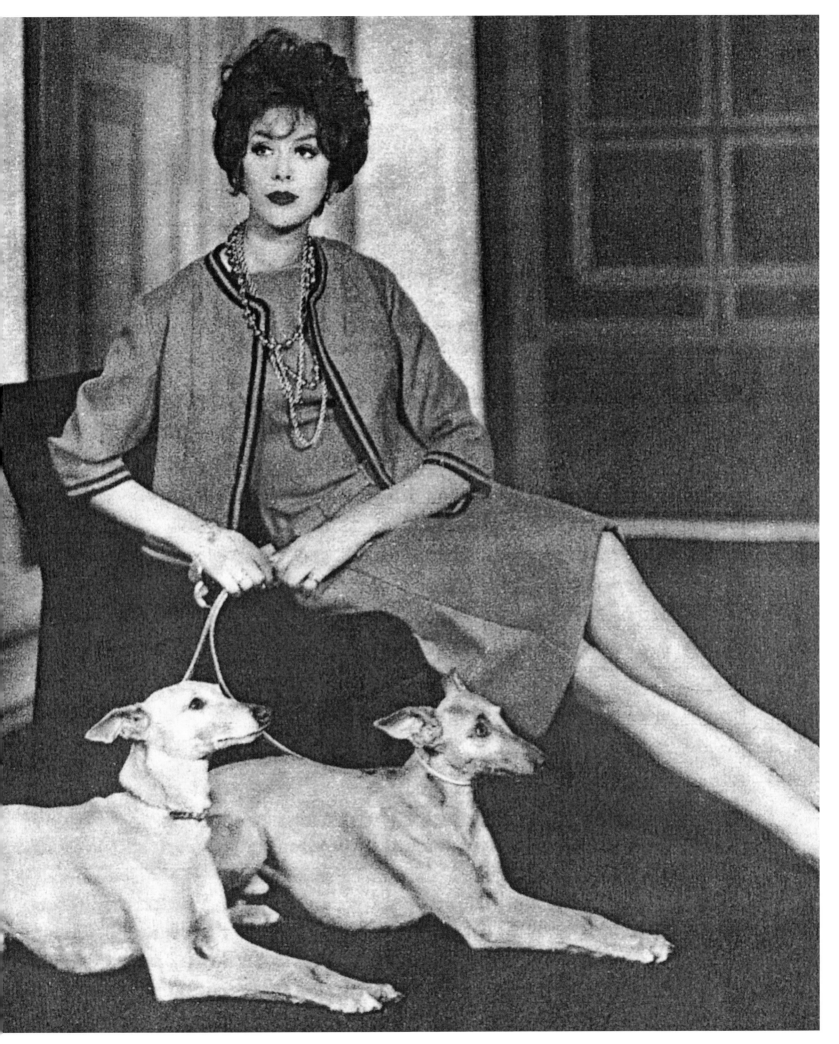

3-6

Fried, Michael,
"A Winter's Tale", *Arts,*
February 1962,
Robyn Denny Archive,
London.

It was Michael Fried, researching in London at the beginning of the 60s, who – apart from Lawrence Alloway's ambivalent support – gave Denny an authoritative and informed backing from a phenomenological position. In February 1962, Fried's London Letter in the New York magazine, *Arts,* titled "A Winter's Tale", hailed Denny's Molton Gallery exhibition as the season's finest one-man show. Fried cited Denny's virtues as being "an unequivocal declaration for certain formal qualities – clarity of organisation, paint density, eschewel of gesture – that haven't till now been present conjunctively in English painting".[3] Fried recognised an independent, non-insular, non-derivative kinship with "recent developments in America (one thinks of Noland, Reinhardt, Stella, for example".[4] The thrust of Fried's review was to extend the phenomenological argument of a virtual inhabitation of Denny's tightly installed paintings, through the framework which Alloway had outlined in his catalogue introduction: "'A formal theme of great importance is that of the threshold, a dramatisation of the X where spectator and art work meet and overlap… Denny's paintings imply an ambience of human use.' At the same time that spectator is invited to enter or grab hold, he is held back by his awareness that these are, after all, merely paintings."[5] Fried nuanced his formalist reading – "Despite their radical symmetry the shapes themselves have nothing to do with geometry as such… only the possibility of significant gesture, of action, for us."[6]

LONDON

The Winter's Tale

BY MICHAEL FRIED

The season's finest one-man show by an English painter was just held at the Molton Gallery. The painter is Robyn Denny, and his paintings are large, ambitious, intelligent. Beyond this they are an unequivocal declaration for certain formal qualities—clarity of organization, paint density, eschewal of gesture—that haven't until now been present conjunctively in English painting. In contrast with the great majority of his compatriots, Denny knows not only what kind of art he wants, but also (and this is perhaps even more important in as permissive a cultural ambience as England provides) what the logistics of his desires force him to do without.

The organization of the picture plane into symmetrical, right-angled shapes and colored stripes in Denny's work is new on the English scene and probably owes something to recent developments in America (one thinks of Noland, Reinhardt, Stella, for example). But this isn't to imply that Denny is a derivative painter; only that he is not an insular one, hung up over how to clothe traditional English subject matter in a degenerate idiom based on action-painting techniques. Moreover the fact that action painting so far has borne mostly equivocal fruit in this country has meant that Denny has not had to define himself in contrast with older English painters. As near as one can tell he simply ignores them.

Despite their radical symmetry the shapes themselves have nothing to do with geometry as such. In a short introduction to the exhibition Lawrence Alloway writes: "A formal theme of great importance is that of the threshold, a dramatisation of the X where spectator and art work meet and overlap . . . the paintings carry analogies to such forms as arch and control board, both of them areas designed according to human scale. Denny's paintings imply an ambience of human use . . ." At the same time that the spectator is invited to enter or to grab hold, he is held back by his awareness that these are, after all, merely paintings—an awareness inspired by the quality and depth of Denny's concern for his medium. The actual handling of paint contributes to this tension: one's response is both tactile to its density and merely visual owing to its reso-

lute, unvarying flatness. The colors are for the most part grave and subtle combinations of blue, brown and red. There is nothing like a painterly gesture in any of the paintings, only the possibility of significant gesture, of action, for us.

Altogether Denny showed nine paintings, the most successful of which seemed to me *Wardrop I* and *Ted Bentley.* In these, colors and shapes were balanced perfectly to produce the kind of over-all effect I have just tried to describe. The other seven paintings were intelligent and, with one exception (*Eckleburg*), well painted; nevertheless I thought they failed to achieve the coherence of the two cited above. Critics in the daily and week-end press, perhaps exhausted from their recent pioneering efforts on behalf of Rothko, either ignored the show or else dismissed Denny in a few patronizing lines as promising, decorative or something of the kind. My own feelings—I trust I have made them clear by now—are that he is among the very best painters in England today.

A few biographical notes: Denny was born in Surrey in 1930, and studied at St. Martin's School of Art and the Royal College of Art through 1957. He has

done a number of murals, one at least in mosaic, and is visiting lecturer at Bath Academy of Art. This was his third one-man show in London.

A second remarkable exhibition this month is that of lithographs by Anatoli Kaplan, "The World of Sholem Aleichem," at the Grosvenor Gallery. Anatoli Lvovitch Kaplan is a Jew, born in Byelorussia in 1902 and educated at the Academy of Fine Arts in Leningrad from 1921 to 1927. For the next ten years he worked as a scene designer then, from 1938 to 1941, on illustrations for Sholem Aleichem's *Kasrilevka.* He was accepted as a member of the Union of Soviet Artists in 1939 and his work, especially twelve *Views of Leningrad during the Days of the Blockade* is well known all over Russia. The present exhibition, his first one-man show in Western Europe, consists of 13 lithographs illustrating Sholem Aleichem stories and traditional folk songs—virtually all of which reveal a graphic presence of the first order.

Kaplan's closest affinity is with Chagall; but whereas the latter's self-conscious art depends for its effect on the overtly poetic or magical, and is often merely precious as a result, the depth of Kaplan's sympathy for the lives he depicts is unmistakable. Where Chagall's work is full of *émigré* nostalgia, I don't think it is going too far to say that Kaplan's illustrations, for all their light heartedness, are shot through with the monstrous immanence of a God whose will is pogroms and gas chambers.

The level of technical achievement

Robyn Denny, *Mayle* (1961);
at Molton Gallery.

Robyn Denny, *Wardrop I* (1961)
at Molton Gallery.

Frontman

1961

Acrylic on canvas

96 x 78 in

244 x 198 cm

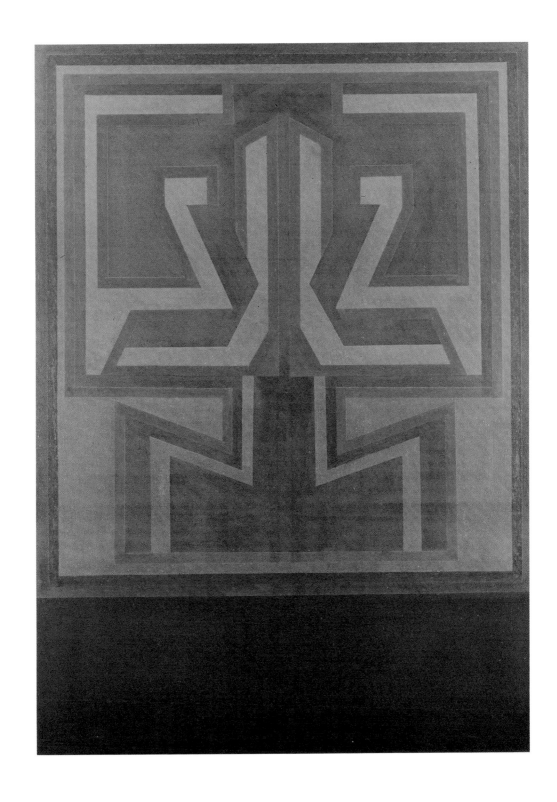

7-9

Alloway, Lawrence,
"The hard-edge has
a soft centre", *Topic*,
2 December 1961, Robyn
Denny Archive, London.

10

Coleman, Roger,
Introduction,
Situation, London: RBA
Galleries, 1960.

11

Coleman, *Situation*.

12

Amos, Jeff, *Alloway,
Denny and 'Situation'*,
unpublished PhD thesis,
University of Sussex, 2000.

13

Originally published in 1947,
it was translated and printed
with a commentary by
Lawrence Alloway, in the
"Day-Glo" *Ark* in 1959.

In one of his last London art reviews before he departed permanently to New York, Alloway had dismissed the applicability of the novelty term 'hard-edge', in relation to Denny, as being "tinsel-bright and shallow".[7] The real issue was spatial play, not technique: Alloway insisted that the actual topic of the best London abstractionists was "scale, and real and imaginary space", placing Denny – as did Fried – apart from geometrical constructivists and on a par with Vasarely, who was also showing in London at the end of 1961 at the Hanover Gallery: "These [British Constructivists] still seem to hold geometry in awe, while Denny uses geometry as the rules in an unclear game and exploits with non-Euclidian glee every possible contradiction that this permits even to the point of near *trompe l'oeil* effects. It is in fact an exploitation of all that can be discovered in the antithesis of real and imagined space".[8] This conjugation of virtual and perceptible spaces, of illusionistic spaces in which the body might revel, find and loose itself – of environmental spaces, has Alloway present Denny squaring "up to the problem of tailored space. Indeed the pictures seem cut to fit the gallery."[9] The metaphor of tailoring – of the body imagined also as a good fit in these pictures – was circulating and present in early 1962 when *Queen* magazine featured a fashion shoot in the Molton Gallery, which shows this "tailored space", with the shortly to be *Ipcress File* actress, then a model, Sue Lloyd, with two whippets and Denny's *Eckleberg* and *Slot*, behind her.

Already, in 1960, Roger Coleman had announced this new intimate kind of space in relation to Denny, Dick Smith and Ralph Rumney's allusive abstract painting, in his "Introduction" to the *Situation* exhibition catalogue in 1960. Put into a state of proximity with the large canvas, "the spectator is contained and confined by it".[10] Here was the pictorial ideology of a certain physical dimension to the compelling formal power of the "big painting".[11] There existed pictorial precedents for this sense of an illusionistic sensuous enclosure and the prospective immersion of the viewer in an abstract-illusionist environment – what Jeff Amos has called "an existential atrium space".[12] Lucio Fontana's appeal to the Baroque as a possible model for avant-garde pictorial practice had just been published in English, in his *Technical Manifesto*: "It is necessary to overturn and transform painting, sculpture and poetry.… The baroque has guided us in this direction, in all its unsurpassed grandeur, where… the images appear to abandon the plane and continue into space."[13] And if the puncturing and scarification of surfaces in Denny's painting reliefs of 1999-2002 have a precedence in Post War art, it is to Fontana's *spazialismo*.

Home From Home
1959
Oil on canvas
96 x 78 in
244 x 198 cm

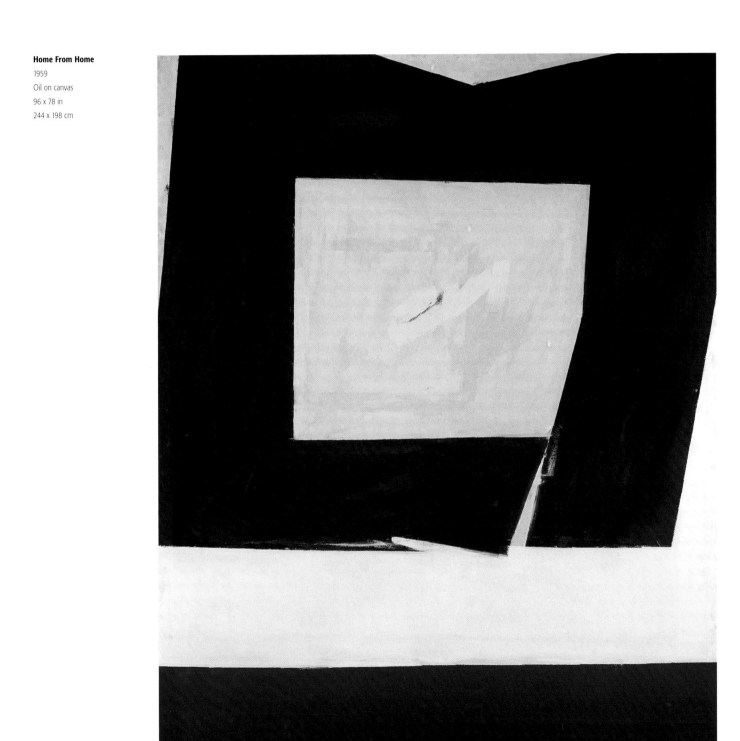

Spaces

Living In
1958 - 1959
Oil on canvas
78 x 96 in
198 x 244 cm

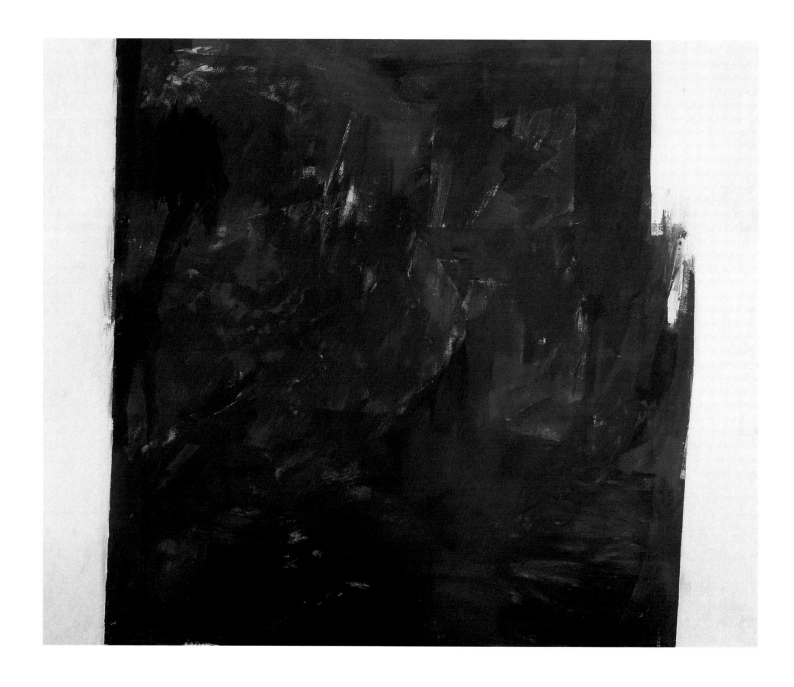

14

Derrida, Jacques,
The Truth in Painting,
Chicago: University of
Chicago Press, 1987, p. 61.

15

Steinberg, Leo,
"Other Criteria",
Other Criteria, Oxford:
Oxford University Press,
1975, pp. 55-91.

16

Coleman, Roger,
"Figure/Field Work",
Art News and Review,
August 1959, Robyn Denny
Archive, London.

The spatial lure for the spectator's body of a place – "the body proper of the *ergon*" – has figured in Denny's large compositions since *Home from Home*, 1959, with its play on bordering, as well as, the virtual coloured potential zones of his abstract paintings, in the late 50s and the 60s.[14] Denny was also implicated in the development of another sort of imaginary space – one that was additive, inventorised, defaced and highly textualised; one that dealt more literally with the surrounding modernising culture. This was elaborated in works such as the letter-form *Abbey Wood Mosaic,* 1958, and *Austin Reed Mural,* 1959, and his lithograph collaboration in the same year with Richard Smith, *Ev'ry Which Way*. There is a subterranean link between Leo Steinberg's theory of the arrival of a distinctively urban-inflected 'flatbed space', and the montages, murals and mosaics which Denny produced in 1959.[15] Roger Coleman pointed out that, unlike the formal painting, *Living In*, the style of the *Austin Reed Mural* was bound by what he called a "stencilled palimpsest", close to the "'ambiguous' figure/field diagrams of perception theory… thus the painter has made a communications channel in which reception is constantly equivocated by a controlled level of 'noise'".[16] Denny and Smith's *Ev'ry Which Way* has an independent status in relation to the onset of Robert Rauschenberg's 'flatbed' spatial format. While it is the case that, in the summer of 1958 the two English artists visited the Venice Bienalle and saw the display of Jasper Johns and Robert Rauschenberg at the Italian Pavilion, Rauschenberg's silk-screens were still six years in the future, so the tumbling transparencies of samples of social modernity in the *Ark* lithograph, which they completed the following year, actually anticipated a strategic move by Rauschenberg, rather than mimicked it. At the same time, the transformation of space and orientation of viewing subject that is implicit in Steinberg's concept of Rauschenberg's 'flatbed' has independent similarities with the elaboration of a permissive, palimpsest space in Denny.

Spaces

below
Robyn Denny working on
the mosaic for Abbey Wood
Primary School, London,
1958.

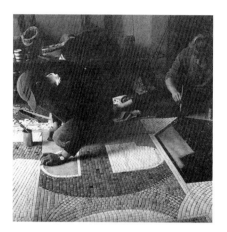

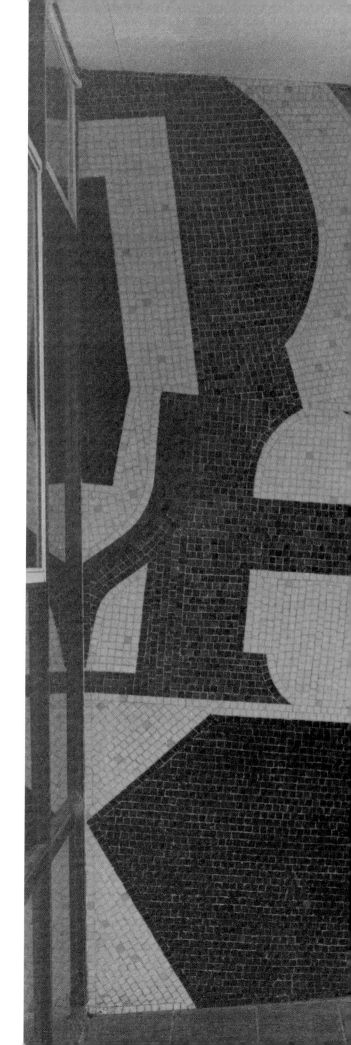

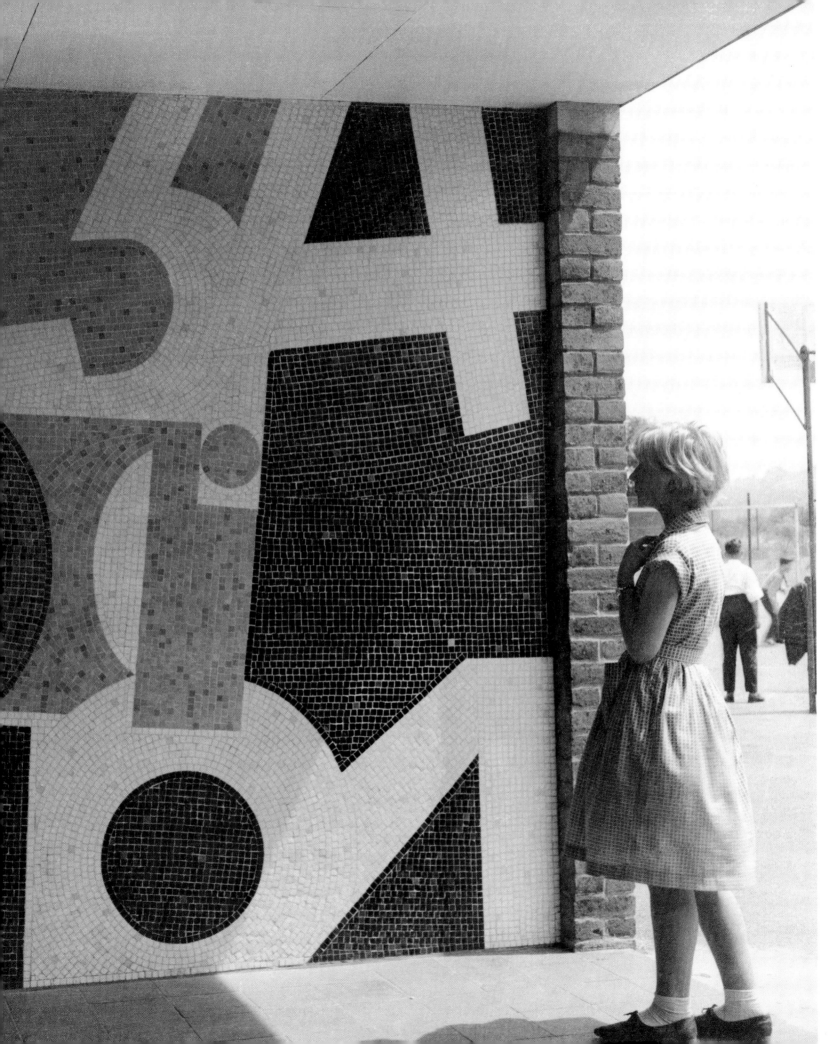

17
Steinberg, *Other Criteria,*
p. 90.

18
Steinberg, *Other Criteria,*
p. 90.

19
Robyn Denny in
conversation with the
author, 12 July 2001.

20
Robyn Denny, London:
Tate Gallery, 1973,
p. 50.

21
Robyn Denny in
conversation with the
author, 12 July 2001.

Leo Steinberg's definition of the spatial revolution effected by Rauschenberg in the 50s rests on a model of irreducible horizontality, yet he assimilated more formalist abstract art to his case: "The flatbed picture plane lends itself to any content that does not evoke a prior optical event…. Color field painters such as Noland, Frank Stella and Ellsworth Kelly, whenever their work suggest a reproducible image, seem to work with the flatbed picture plane, i.e. one which is manufactured and stops short at the pigmented surface; whereas Pollock's and Louis's pictures remain visionary…."[17] According to this schema, are Denny's abstract paintings "visionary" or do they "suggest a reproducible image"? The answer indicates the extent of that shift which took place after 1977, when Denny passed from the calculable world of rectilinear geometries and forms, which he had adopted in 1960, to one of incommensurable diffusions and torn symmetries. Once he had passed over – in the early 80s – Denny's paintings resumed the appearance of a certain European tradition; what Steinberg called, "the vertical posture of art".[18] And, in one of his most recently completed *Footlights* paintings, he entertains a relationship with those bannered Catholic paintings of the fifteenth, sixteenth and seventeenth centuries which mediate levels of heaven and earth, such as Fra Fillippo Lippi's negotiation of the zone above the altarpiece of the Caraffa Chapel in S Maria Sopra Minerva in Rome.

For Denny, those predominantly vertical architectonics from the 60s, with their metaphors of ascension, were opened up laterally and levelled in stepped, shining and chequered distinctions across his 'Horizontal' paintings of 1970-1971. There was, at the beginning of the 70s, an embarkation upon that linear and lateral expansion which Denny was to make the dynamic of the *Sweet Nature* and *Travelling* series of c.1976-1977. *Sweet Nature* was composed of stepped orthogonal branches which, in Denny's words, "… began to grow".[19] Denny had already suggested to the curator of his 1973 Tate Gallery retrospective, Robert Kudielka, the instance of a two-part Victorian sculpture of "… two cricketers, a bowler and a batsman, placed at opposite ends of a room in such a way that the empty space which separated them was articulated by the activity which connected them."[20] Horizontality carried a baggage of meanings: "I'm entranced by the notion that art resides in the space that separates the works – in negative space, but connected… like a frieze".[21] Waddington's October 1977 catalogue reproduced an overlay of works on paper from his *Sweet Nature* series, with its titles' connotations of benign growth, a branching movement which recalls the stepped cellular paintings of trees by Mondrian. But what could be said to work counter to this almost Constructivist vector is the shaggy paint and torn paper ribbons of several of the more informal works on paper.

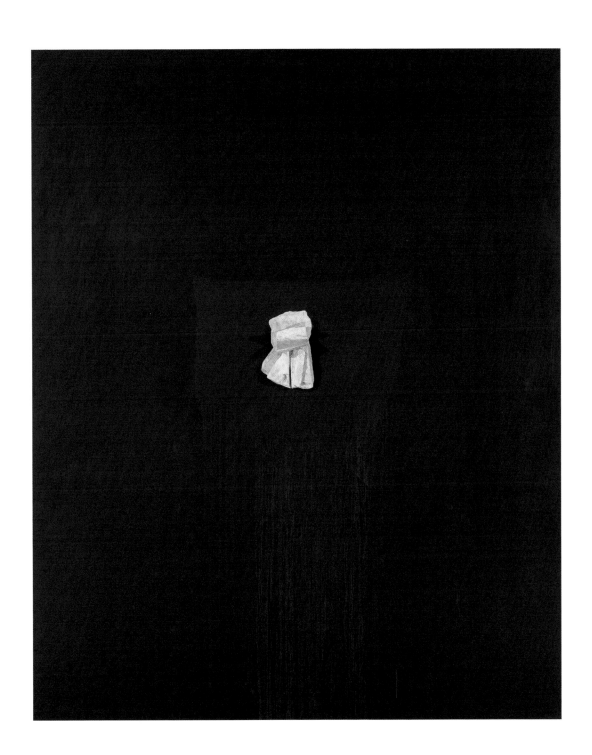

Spaces

World Wide 1
1970
Oil on canvas
64 x 72 in
162.5 x 183 cm

opposite
World Wide 2
1970
Oil on canvas
64 x 72 in
162.5 x 183 cm

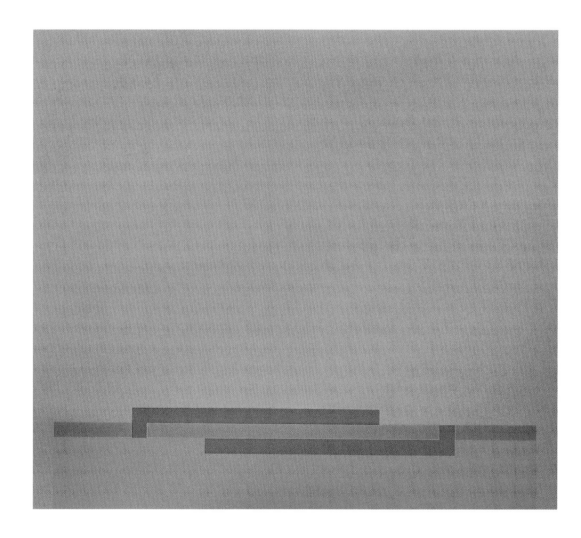

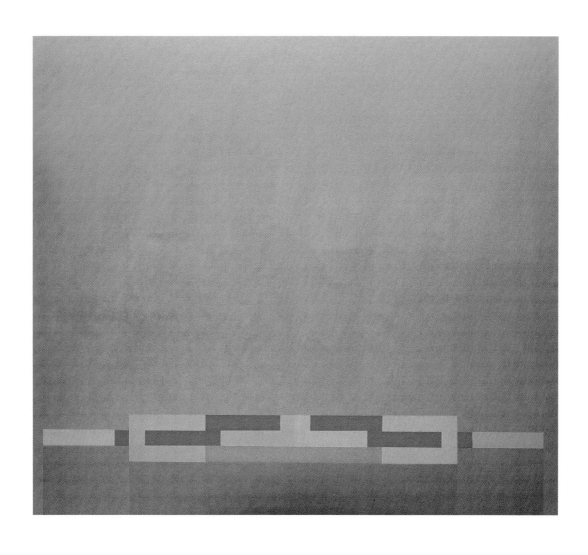

Spaces

Glass 2 From There
1971
Oil on canvas
108 x 144 in
274 x 366 cm

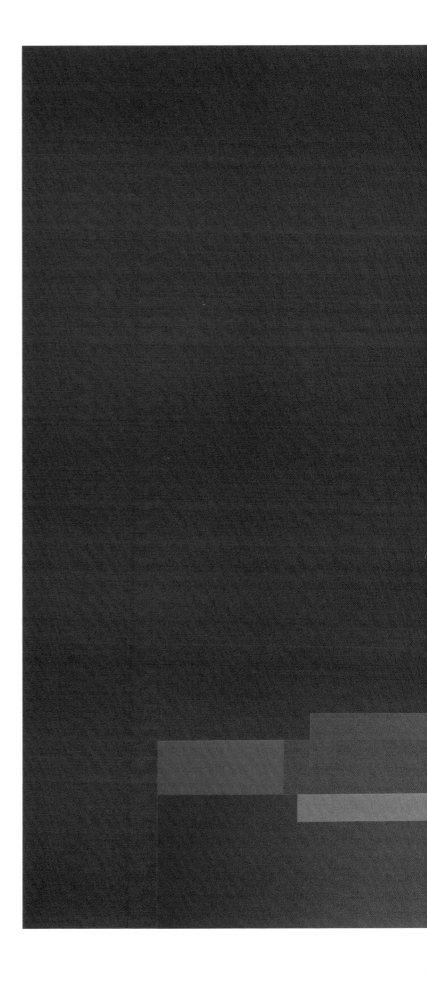

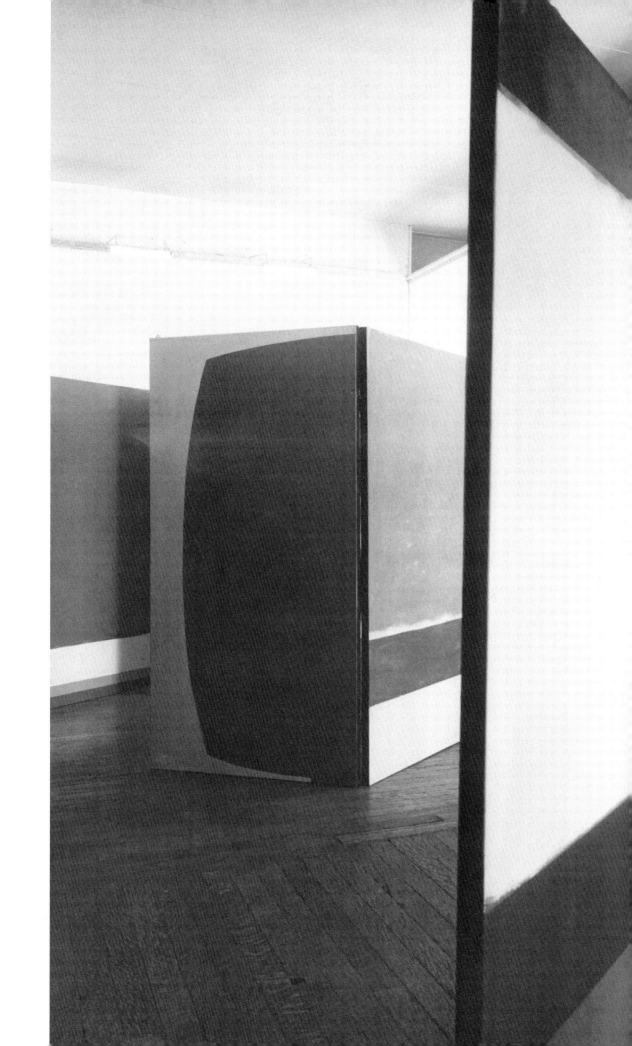

Place exhibition, ICA,
London, 1959.

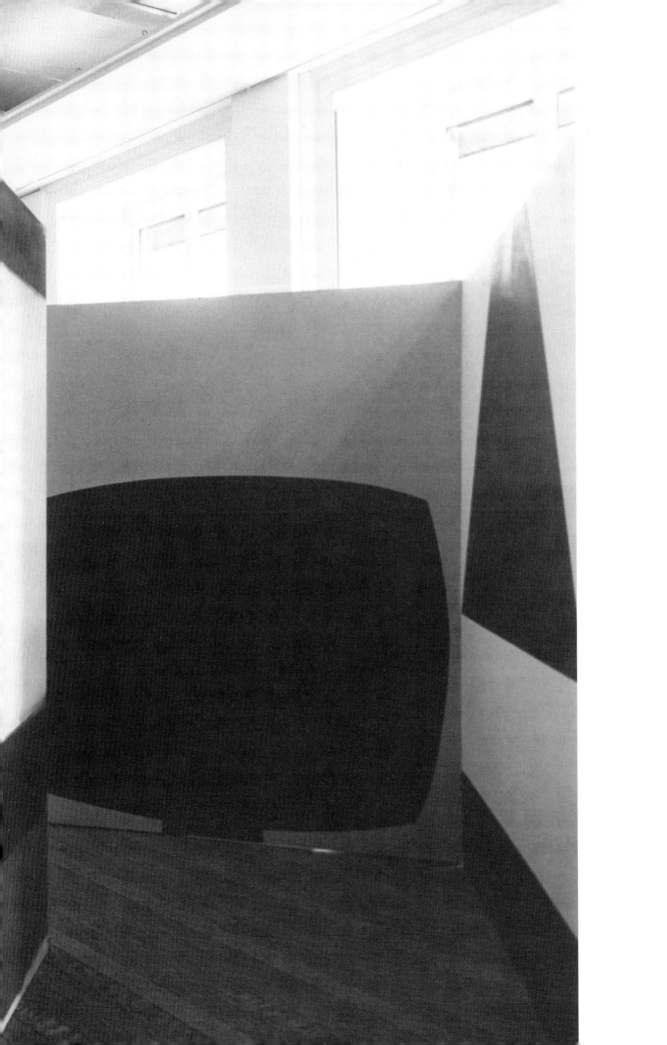

Spaces

Travelling 2
1976 - 1977
Oil and oil crayon on canvas
84 x 72 in
213.5 x 183 cm

opposite
Travelling 4
1976 - 1977
Oil and oil crayon on canvas
84 x 72 in
213.5 x 183 cm

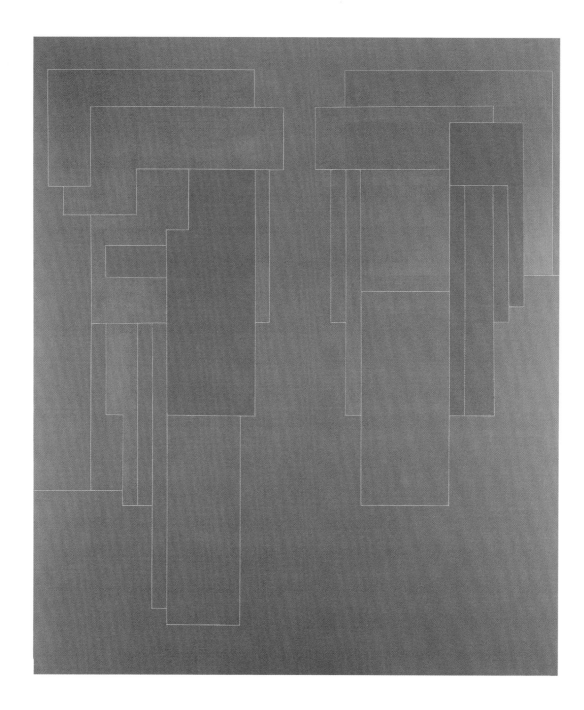

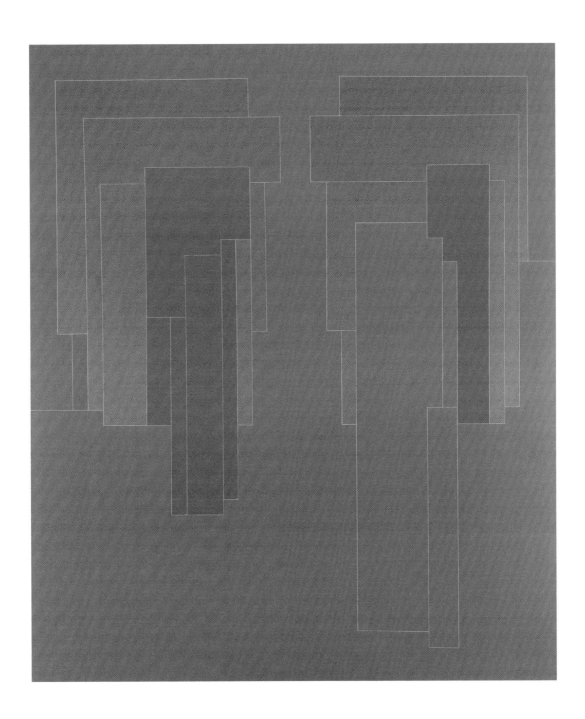

Spaces

22
Pollitt, J J, *Art Criticism in Antiquity,* New Haven and London: Yale University Press, 1974, pp. 15-23 (esp. p. 16).

Sweet Nature spread and re-invented itself in altered geometries; in total, the separate painted segments were parts of a surrounding, symmetrical whole: it maintained an Apollonian stance in the paintings, but in the works on paper – crucially – it had its surface broken by ragged paint or paper knots. This disruption of surface is absent from the much larger *Travelling* series which were shown at the Hayward Annual in 1978. The enclosing, orbicular, *Travelling* fulfilled his wish to surround the spectator with a constructed environment of paint in ways which looked back to the ICA installation *Place*, in 1959. But *Place*, while it tried to posit subjectivity, was not a painted space which suggested the presence of "little secrets". In *Travelling*, scarcely seen cloudy painterly pressures seem to rise from below the picture plane and smudge the white line channels which mark the rectangular perimeters of verticals which hang, flatter than flat. These are the thermals which will blow through the Californian paintings of the following decade, in airy paintings such as *Razzle Dazzle* and *Windward Steam and Angel Dust*.

Some force of incommensurable animation had arrived and in the sole *Travelling*, which Denny still owns, the aggregated structures have some resemblance to Kandinsky's organisms of the early 1940s; that is, in their thin, floating wandering, they grow lively. Denny had five paintings from the series photographed together by Prudence Cuming, overlapping, as if having a conversation; animatedly transferring features and information between themselves. From the later 70s, this murmuring, this noise of incommensurability bears in upon Denny; first as the soaked and coloured surfaces of scarred paper; then as a puncturing and finally scribbled white light. J J Politt has suggested that symmetry's originary role in Western representation, was as a device giving commensurability against a preceding, archaic Greek, perception of a universe in flux; "a limit (*peras*) on an infinitely variable mixture of phenomenon": a position which, we could say, is allegorically recapitulated in Denny's long term dialectic of informally figured depths and scribbled complexities, as countervailing to his grand planar symmetries – the contrast of *to apeiron*, the unlimited, and *to peperasmenon*, the limit, the unit, the odd and the even.[22]

Sweet Nature 4

1976 - 1977

Oil on canvas

78 x 120 in

198 x 304.5 cm

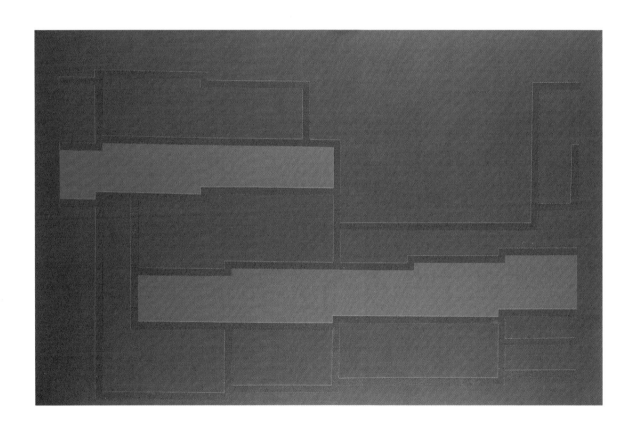

The Golden Gospel
1963
Oil on canvas
84 x 72 in
213.5 x 183 cm

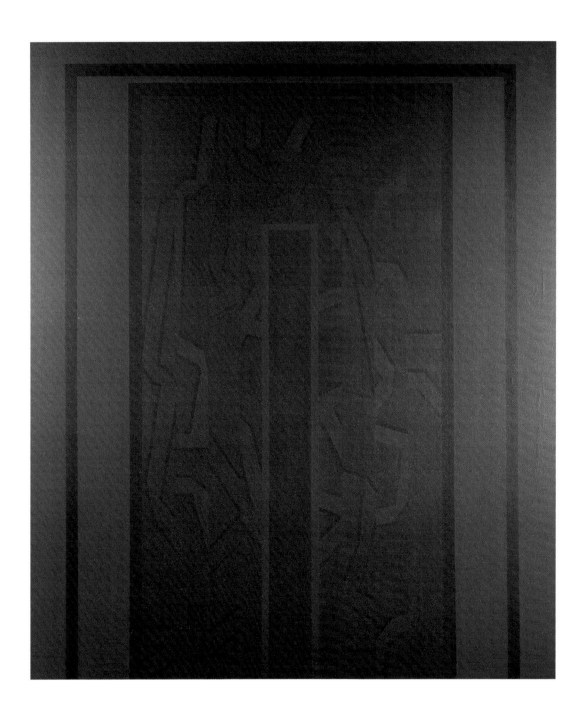

23
Lynton, Norbert, "Natural Art", *The New Statesman,* 20 March 1964, Robyn Denny Archive, London.

24
Pollitt, *Art Criticism in Antiquity,* pp. 230-231.

25-26
Kudielka, *Robyn Denny,* p. 39.

Reviewing his first Kasmin Gallery exhibition in 1964, Norbert Lynton was at pains to retrieve a persistently Apollonian, classicising element based on the movements of the human body in Denny's painting, leading him to draw Vitruvius and phenomenology together: "For Denny the picture is man, and he demonstrates that the potency of an image relates directly to its receptivity as an extension of our bodily awareness… he can also be seen as the true heir to the tradition of classicism – the tradition of idealised anthropomorphism…. The distance between Leonardo's drawing of Vitruvian man and Denny's canvases is not great." [23]

But this asserted abstract 'classicism' should be read dynamically in terms of countervailing pictorial tensions. In the orthographies which Denny lined his early 60s paintings with – particularly the *Out-Line* and *Line-Up* series of 1962 – there is an *orthographia* – sets of ideal monumentalities, of risen spatial planes without volume or sides, planes which are primarily frontally ordered and oriented. [24] However, even by 1964, Denny's dialectic of limits and incommensurables had moved towards an unregulated sense of transversal, randomised dimensions and filleted volumes which flickered and circulated in a complex and unstable way in the remarkable paintings which Robert Kudielka nominated as 'asymmetric', such as *Connections, Golden Gospel, Secrets* and other works of this period. Between 1963 and 1965 Denny passed through a welter of auto-iconoclasm, diagonally disrupting the more orthographically structured designs he had already outlined and present on the canvas with gestures of cancellation: "… it was by continuous obliteration that Denny modified the rectangular structure". [25] What prompted this, Kudielka speculates, was an anxiety on Denny's part that frontality had become too overwhelming and un-negotiable for the viewer: "… the frontal impact of his paintings could easily repel the spectator". [26] One series of these over-paintings were a group of smaller canvases which Denny called *XSS* followed by a completion and storage reference numbers; works deleted and torn by a Dionysian excess of revisionary painterly desire, gesture and signage – a veritable XS. These cancellations and catastrophic revisions look back to the physical ruination of representation in his 1957 mosaics and forward to the distressings of *Moonshine* and *Pepsi Tokyo*, as well as the landslip-like rents on the surfaces of his painting reliefs of 1999-2002.

opposite
Robyn Denny and
Richard Smith
Ev'ry Which Way (detail)
1959
Lithograph.

Denny's art, as the 50s ended and the 60s began, was shaped by the exhilarations and terrors of the larger social experience of one of the most acute passages of modernisation in the history of the West. A kind of talisman of this change and the corresponding episode of cultural modernity can be found in Denny and Smith's lithograph, *Ev'ry Which Way* of 1959. Here, a multi-dimensional space of overlapping photographs and scribbled annotations unfolded from the habitat of a car-borne and computer-commensurable earth, through a realm of artificial light. It is a jostle of montaged, tumbling, space-suited and film star portraits, an extra-terrestrial, stellar world, which could also contain a blue-dyed Japanese painter-monk. Published under Roddy Maude-Roxby's editorship of *Ark*, in the "Day-Glo" issue of 1959, *Ev'ry Which Way*, printed as a lithograph gate fold, finally unfolds to a film strip showing the proto-skinheads Denny and Smith talking in a studio, juxtaposed with two, signed, reproductions of paintings by them, set at 90 degree angles to each other.

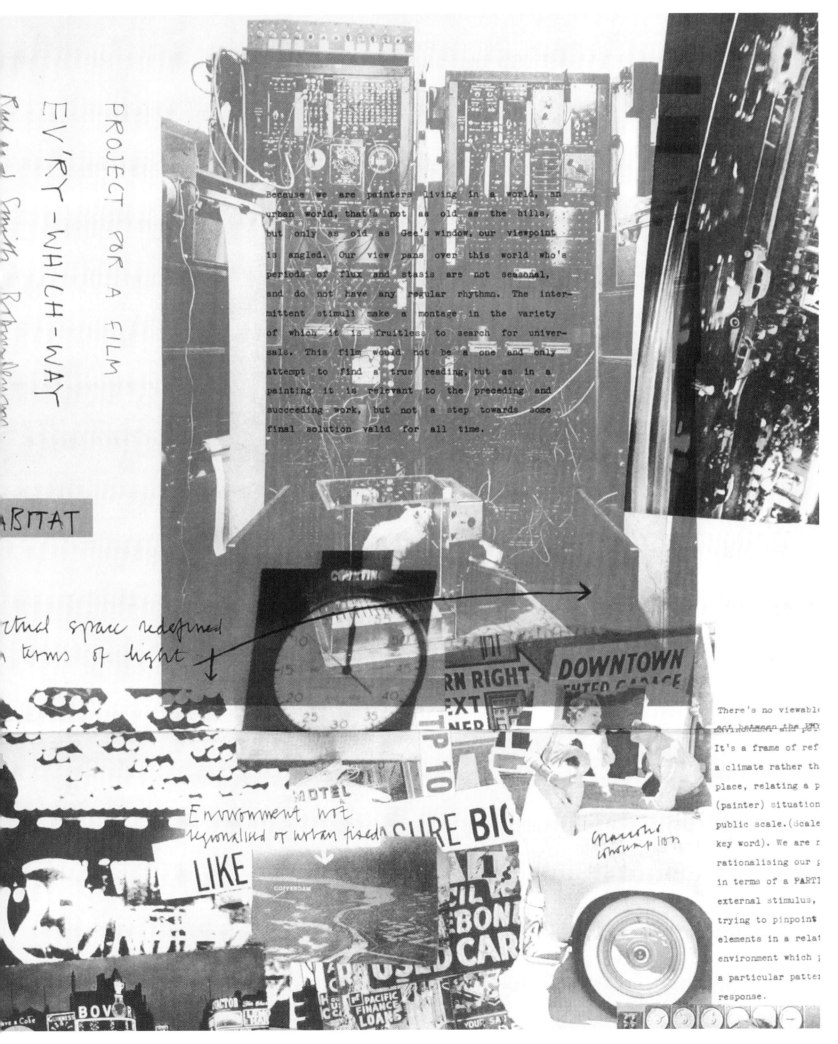

PROJECT FOR A FILM

EV'RY-WHICH-WAY

Rachael Smith Retrospective

HABITAT

Because we are painters living in a world, an urban world, that's not as old as the hills, but only as old as Gee's window, our viewpoint is angled. Our view pans over this world who's periods of flux and stasis are not seasonal, and do not have any regular rhythmn. The intermittent stimuli make a montage in the variety of which it is fruitless to search for universals. This film would not be a one and only attempt to find a true reading, but as in a painting it is relevant to the preceding and succeeding work, but not a step towards some final solution valid for all time.

actual space redefined
in terms of light

Environment not regionalised or urban fixed

LIKE

There's no viewable
act between the PHY
It's a frame of ref
a climate rather th
place, relating a p
(painter) situation
public scale.(Scale
key word). We are r
rationalising our p
in terms of a PARTI
external stimulus,
trying to pinpoint
elements in a relat
environment which
a particular patter
response.

1
Blanchot, Maurice,
"The Conquest of Space",
The Blanchot Reader,
Michael Holland ed., Oxford:
Blackwell, 1995,
pp. 269-271.

2
Blanchot,
"Conquest of Space", p. 269.

3
Blanchot,
"Conquest of Space", p. 270.

This mobile, horizon-less pictorial space was linked to the larger cultural and technological spaces of contemporary thought and philosophy. Maurice Blanchot's essay "The Conquest of Space", was the essential commentary to this moment in Denny's work at the turn of the 50s.[1]

Blanchot' s text of 1961 examined the revolution in the human imagining of spatiality in the epoch of the first manned Earth orbital flight. He begins with an image of immobile, lethargic, cautious humanity: "Man does not want to leave his place (*luogo*). He says that technology is dangerous, that it detracts from our relationship with the world…. This man suffered a shock the day Gagarin became the first man in space… man has freed himself from place…. Man, but a man with no horizon."[2]

Blanchot hailed the departure from an 'encrusted' tradition of the land and in *Ev'ry Which Way*, one of Denny's annotations reads "Environment not regionalised or urban fixed". Blanchot suggested that a consequence of the astronaut's conquest of space was "this sort of levitation of man as substance, as essence obtained by breaking away from 'locality'" insisting on the nomadic nature of truth and existence in a lyricising of the spatially emancipating effects of technology.[3] For the younger generation of RCA painters, the orbital and sub-orbital flights of 1961-1962 were catalysts for their newly figurative art: for example, Derek Boshier's painting *I Wonder what my Heroes think of the Space Race*. While Pop was being pioneered in that crucial period, and Richard Hamilton condensed American football iconography with astronautics, Denny turned to a kind of metaphoric abstraction which had associations with circuitry and the grammar of popular games: the illustrative literalism of an intoxication with the unlimited (*to asperion*) of Blanchot's "astral era", in *Ev'ry Which Way*, was replaced by a more mediated and orthographic exploration of the forms of gravity and place.

Candy
1961
Oil on canvas
72 x 72 in
183 x 183 cm

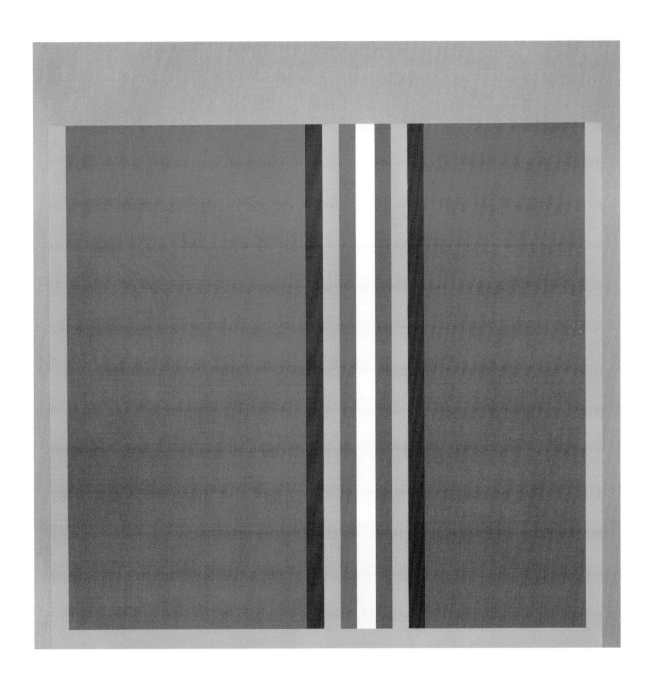

Modernity

Track 4
1961
Oil on canvas
72 x 72 in
183 x 183 cm

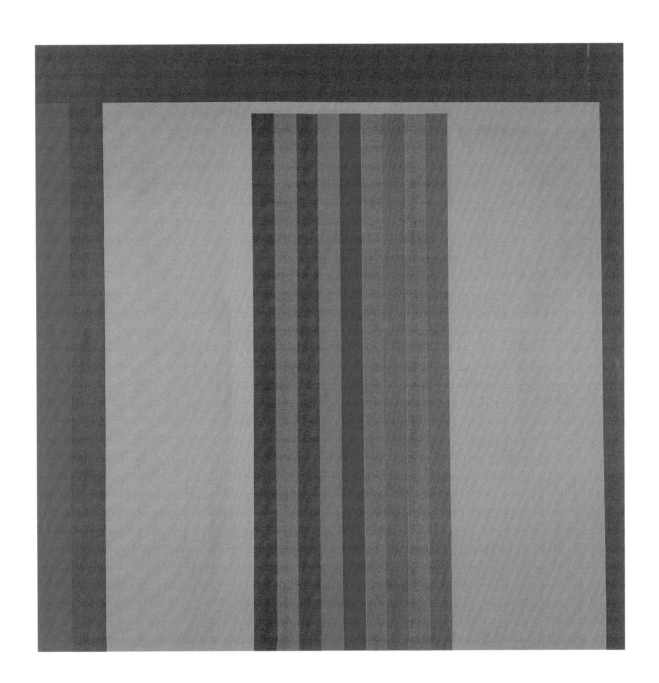

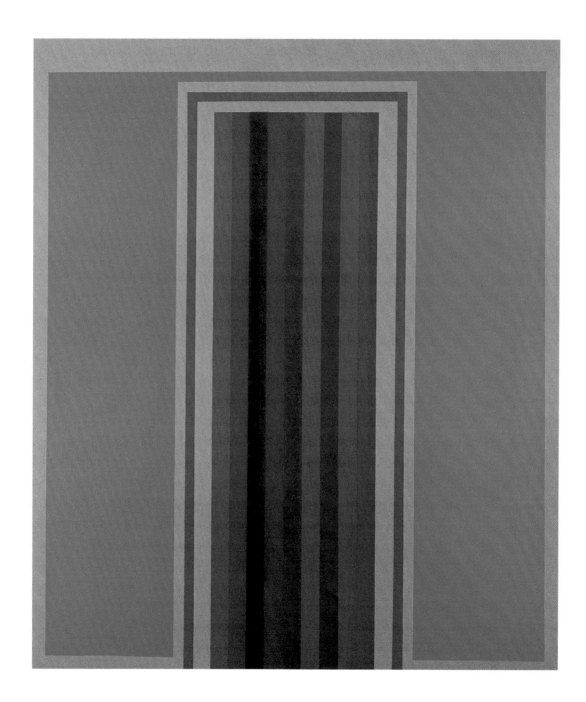

Modernity

4
Denny, Robyn,
"The Creative Process",
*Conference on Design
Methods,* 1963,
pp. 185-193.

5
Denny, Robyn,
"Note 3", undated, Robyn
Denny Archive, London.

6
Denny, Robyn,
"Note 3", undated, Robyn
Denny Archive, London.

7
Thompson, David, *Robyn
Denny,* Harmondsworth:
Penguin, 1971, p. 29.

8
Lyotard, Jean-François,
"Time Today", *The Inhuman,*
London: Polity Press, 1993,
pp. 57-77.

For Denny, a primary inspiration for this new spatial paradigm, around 1959-1961, came from science fiction writers such as Theodore Sturgeon, Phillip K Dick, Isaac Asimov, Brian Aldiss and Frank Hampson. They augmented that strong interest in more canonic Modernist writing – F Scott Fitzgerald, T S Eliot – which is also evident as a source for Denny's visual imagination, providing, as he said, a provocative "unexpected concord between Asimov and Tolstoy".[4] The vertical ribbons of colour inside the mysterious portals and delimited centres of *Ted Bentley* and *Gully Foyle,* suggest data-streams of universal information held in cyberspace, uncanny polychrome flows, kin to Noland's stripes, but relocated in a sharply pressed and repressed planified space. In a pencilled note on these two paintings, probably made in the year they were fabricated and shown at the Molton Gallery, Denny found common issue with science-fiction's charting of human power and action under future conditions of advanced space travel. *Gully Foyle,* he wrote, was concerned with the phenomenology of deep space dimensions: "… where man's experience of 'real' space is in tension/conflict with his perception of 'synthetic' (galactic) space. A synthetic situation involving a conflict (of) dimensions, time and space."[5] Denny had derived the title *Ted Bentley* from the eponymous hero of *World of Chance* by Philip K Dick, where "the acquisition of power and the control of human behaviour invokes the Theory of Games (and) the realisation of a 'controlling' posture, through a game situation".[6] David Thompson has pointed out that *Gully Foyle,* had its origins in a story of an astronaut lost in space "… a human consciousness measuring itself against the immeasurable".[7] It was this process – of corporeality extending itself across incommensurable space – which occupied Denny in the high 60s.

The figuring of a Sublime scale is important in Denny's art and one of philosophy's attempts to imagine the organisation of vastness, through the concept of the monad – a massive co-ordinative social entity – was present at many levels in the imagination of the 60s. For example, the students at Chelsea School of Art produced a magazine called *Monad* in the summer of 1964: the year of the election of a government committed to large unit organisation of public life. At the ICA, and with the Independent Group, in the mid and late 50s, there had been a kind of ideological preparation for this modernised world of complexification and control, the world of 'neg-entropy' – the capacity for condensing and retaining information and memory which would create a planetary monadic world as Lyotard has described it: "The electronic and information network spread over the earth gives rise to a global capacity for memorising which must be estimated at the cosmic scale…. The body supporting that memory is no longer an earth-bound body."[8]

9

Heidegger, Martin,
*The Question Concerning
Technology,* Lovitt, William
trans., New York:
Harper Perennial, 1991,
pp. 115-154.

10

Heidegger, *The Question
Concerning Technology,*
p. 152.

11

Heidegger, *The Question
Concerning Technology,*
p. 135.

Such a planetary vision had been explicit in Martin Heidegger's essay "The Age of the World Picture", which might suggest a comparative philosophical perspective on to the metaphors generated by Denny's sublime slabs, in a technologically determined, culture.[9] Man, according to Heidegger, is framed by the compelling sovereign power of these vast entities and their "total… technological rule over the earth".[10] He recognised the techno-sublime 'gigantic' inherent in processes of Americanisation and the processes of enframing the world, which

> presses forward… that through which the quantitive becomes a special quality… as soon as the gigantic in planning and calculating and adjusting and making secure shifts over out of the quantitive and becomes a special quality, then what is gigantic, and what can seemingly always be calculated completely, becomes, precisely through this, incalculable. This becoming incalculable remains the invisible shadow that is cast around all things everywhere when man has been transformed into *subjectum* and the world into picture.[11]

These metaphors of luminosity being subdued and concealing the emitting of light as revelation have a certain resonance in alignment with Denny's motifs – of the looming gigantic, and of the muting and suppression of light and secrets. They sound through the work of Robyn Denny and are most evident in his poetic titling: that gamut of diffusion and mystery suggested by – *Seeing Things*; *Shadows*; *Ghosts*; *And Glory in the Air*. The big monad – that gigantic, incorporative sign of the culture of modernity and modernisation – faces us and enframes us. From inside its bounded surface it has the aura of immanence and from 1982, this incalculable 'invisible shadow' flares up as an uncanny, negative light – up from the bottom of the picture: then, in the most recent pictures, this negative shadow becomes a cast flare, a secretive, squinting thing, in *Footlights 2* and *Shadow Rising*. Between omnipotent architectonics and melting, hued nuances: between the daunting confrontation with the enframing *Gestell* and the oneiric, visionary screen, are primary divisions in Denny's art.

Transformable 1

1959

Nine interchangeable sections

Painted composition board

15 x 15 in

38 x 38 cm

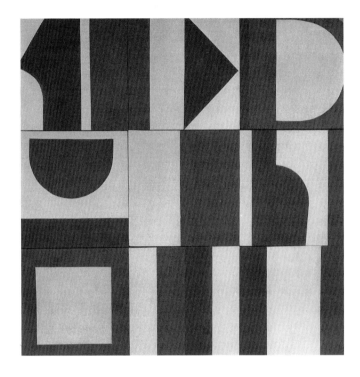

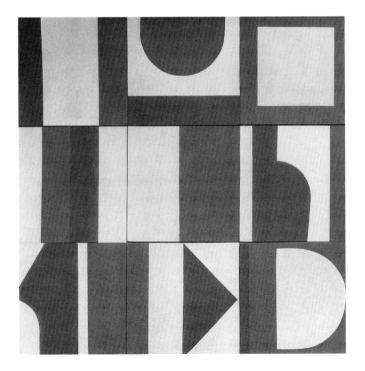

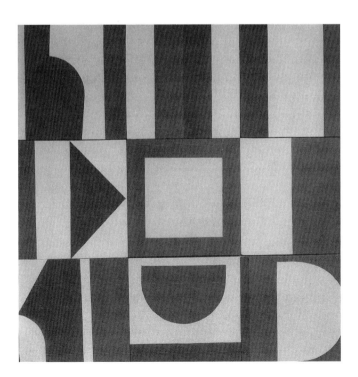

12
Transcript of
"Discussion on Participation",
Corsham Court,
1959-1960,
Robyn Denny Archive,
London

Ellsworth Kelly
New York
Exhibited at US Embassy
Grosvenor Square, London
1958

We can establish, then, that at the turn of the 50s and 60s, Denny was responding to a movement of larger social modernisation which enshrined new rhetorics of space and gave priority to concepts of 'communication' and 'participation'. In 1959 Denny's work on *Place*, in the maze projects with his students at Corsham and in the *Transformable* combinatory reliefs, there was a ludic and environmental direction, as inflected by the emergent disciplines of Behaviourism, Cybernetics and Game Theory. In a transcript of a discussion at Corsham Court in 1959-1960, between himself and Malcolm Hughes, Denny spoke of "Urban people who are contained in an urban environment and conditioned by it", while the countervailing concept of 'participation' was derived by Denny from the writings of the sociologist Daniel Lerner who had argued for an active model of the consumer-citizen, believing that a "genuine participant society" entailed: "a money handling, literate, opinion forming, media-consuming, urban people".[12] It was symptomatic of Denny's preoccupation with the notion of Modernism and the city that in that year of 1959, it was influences which played with metropolitan iconography in a montage manner which engaged him. He had bought a copy of William Klein's frantically juxtaposed book of images of New York, *Life is Good and Good for You in New York*, in the summer of 1958, and in the autumn, at the newly opened United States Information Service in London, he had seen the large *NY* canvas by Ellsworth Kelly – emblematic of New York, and an undoubted model for Denny's emblematising of London in the *Austin Reed Mural*, 1959.

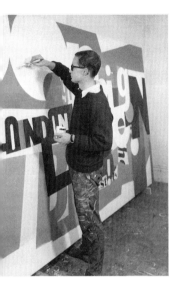

13
Sandler, Irving,
"Robyn Denny,
interviewed by
Irving Sandler, London,
Summer 1961", typescript,
Robyn Denny Archive,
London.

14
Typescript,
Robyn Denny Archive,
London.

15
Russell, John,
"Beginning Again",
Sunday Times,
11 March 1973,
Robyn Denny Archive,
London.

16
Russell,
"Beginning Again".

above
Artist completing the
Austin Reed Mural
1959

right
The Beetles in front of the
Austin Reed Mural
1963

The pragmatism of Denny in the late 50s: open to the world, he refused the moralising of a Constructivism and geometrical abstraction. Proceeding from a newer tradition of Post War information theory and the modelling of an open society, Denny found the ethical fences of a Constructivist tradition, in its relationship to prior notions of modernised, urban experience, no longer vital in the face of the more contingent actualities of the urban landscape of graffiti, signs and rapid human mobility: "I am interested in public art and in urban art – public art as apart from studio art. Mondrian was interested in ideas of what the world should be like… I am interested in what urban art is." [13] With all his public commissions into the fabric of schools, offices, stores and hospitals in London, he has carried an abiding awareness of the interruptions and intersections of the city – its flows – in an almost Situationist manner. The passages, flows and obstructions of street and shop window sites challenged him with mural projects such as the *Portuguese Airlines Office*, 1961, and the *Austin Reed Mural*. Concluding with the *St Thomas' Hospital Panels*, 1974, his London installations became a set of dynamic transparencies. This spatial ambience was important to his art, as he wrote in an early text of 1958, "Outside-In/Inside-Out", which drifted between London's street and studio space, street tableaux with "… no distinction between artwork and playtime… it would be difficult to trace this widescreen palimpsest through to an edge to edge paint trail, for a Thunderbird may have slid by meantimes". [14]

Such a text – foundational to the rhetorics of a culturally renovated and dynamised London as a site of democratic and modernised urban pleasures – places Denny as an indispensable figure in that modernising revolution in British culture which occurred as the 60s got underway. This was the conclusion of John Russell, when he remarked Denny as an energetic and prominent participant in "the solemn moment in the late 1950s when it was decided that English art must start again from the beginning". [15] Russell established this episode, as a moment similar to other breaks such as the PRB's in 1848, the Vorticists in 1914 and Unit 1 in 1934. That is to say, the *Situation* exhibition of 1960, fomented by Denny as Secretary and organiser, stood for another point of departure in the history of vanguard art in England. It was one more episode in a larger national modernisation too, Russell argued in 1973 – possibly writing at the last point in twentieth century British culture when this could be articulated. The shift that had occurred had "… helped us to adjust, around 1959-1961, to social and cultural changes which cut a deep trench between present and past". [16]

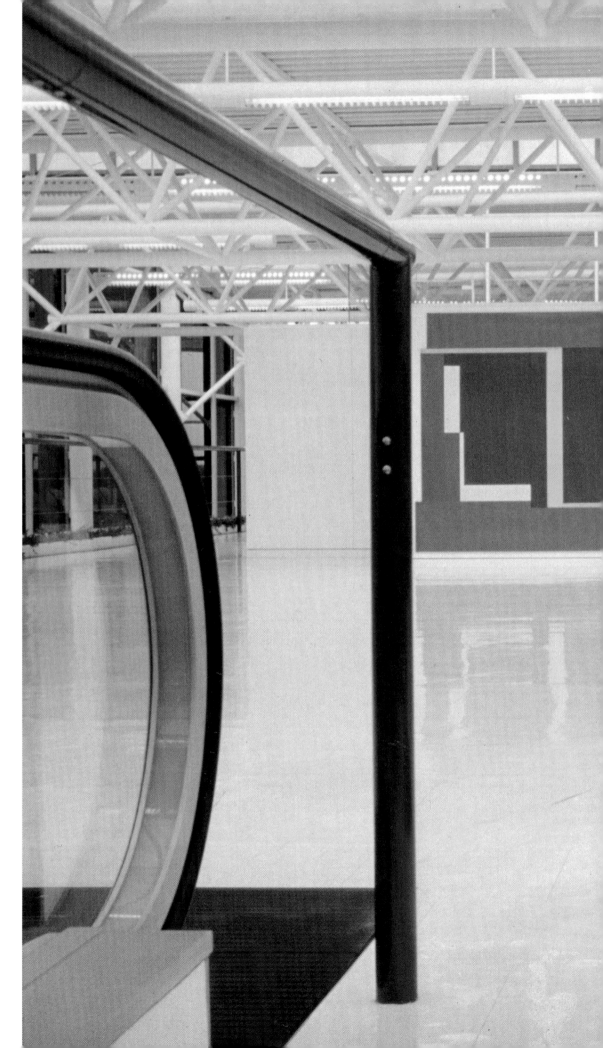

**IBM UK Headquarters
Building**
1982
Large enamel screen in the
main entrance lobby.
Arup Associates,
commissioning architects.

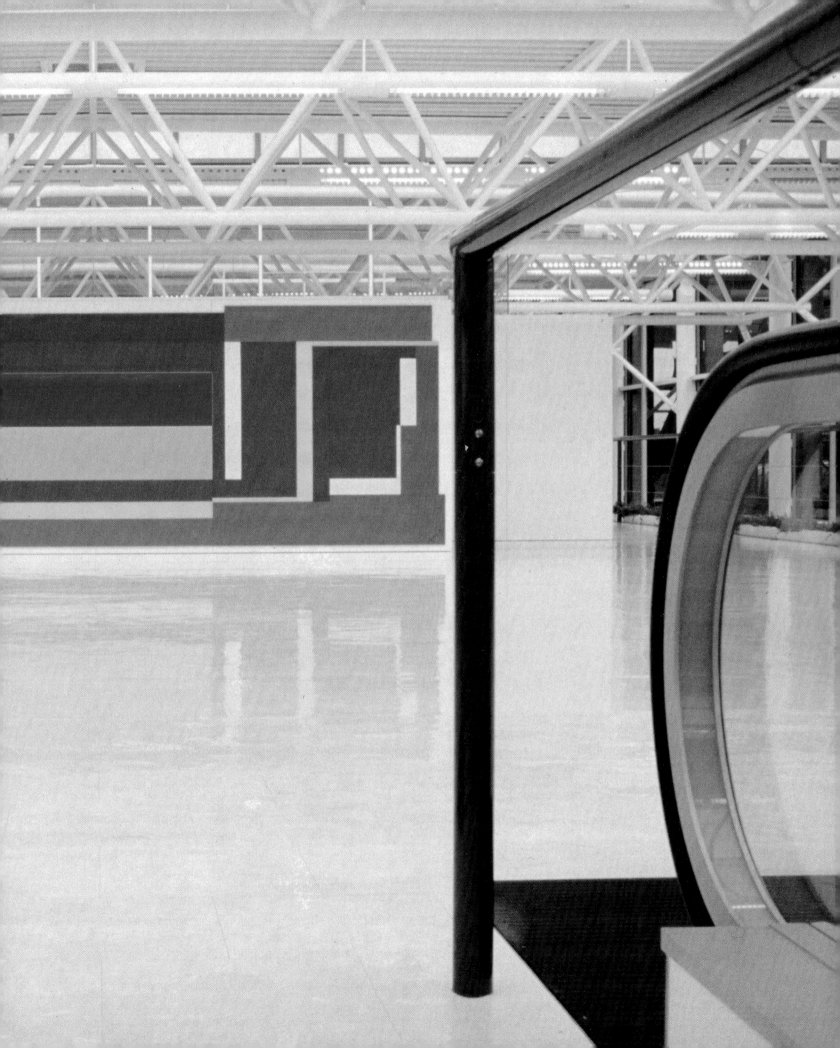

Modernity

right
**St Thomas' Hospital
Panels**
1974
London
Series of six large
enamel panels in main
entrance lobby.
YRM, commissioning
architects.

below
**Portuguese Airways
Headquarters Building**
1961
London
Mural
Verity & Beverley,
commissioning architects.

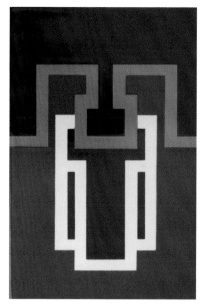
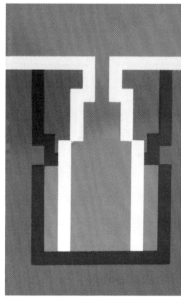

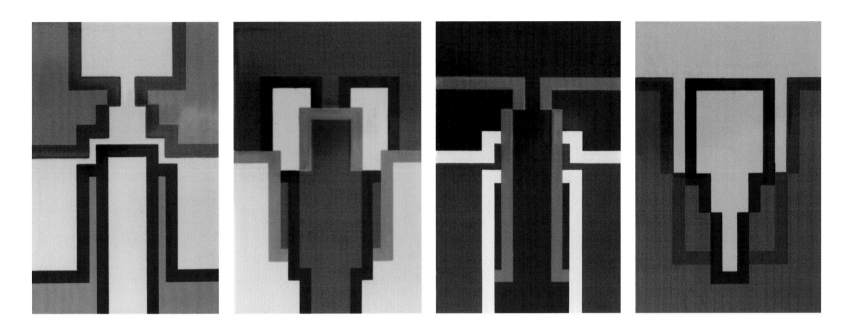

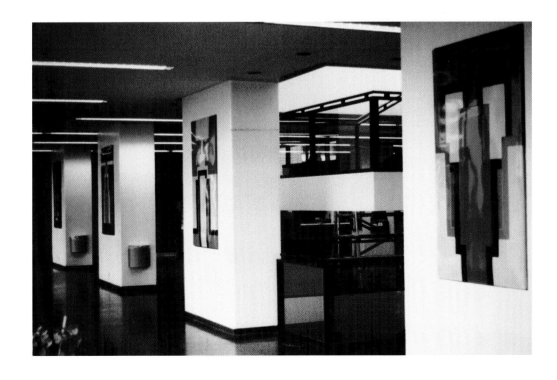

Acoustic mural

1968
Paramount Cinema
Lower Regent Street,
London.
Verity & Beverley,
commissioning architects.

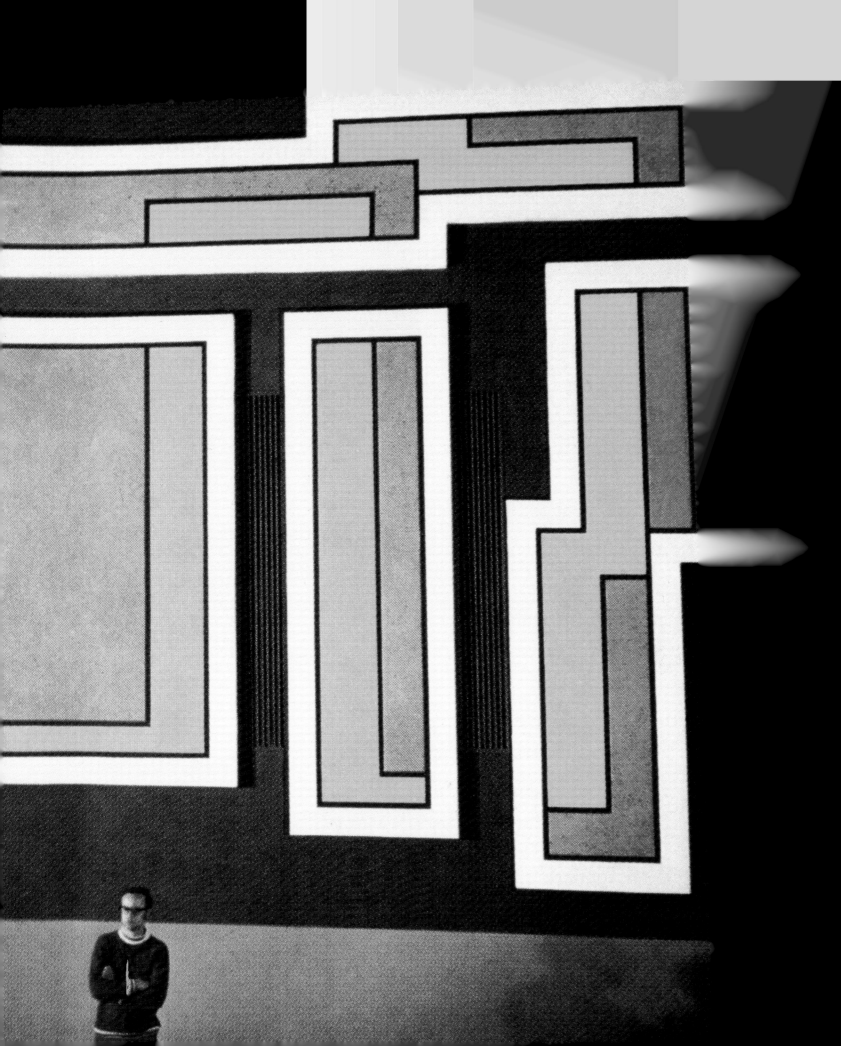

17
Robyn Denny in
conversation with
the author,
20 December 2001.

18
Denny, Robyn,
"Bomberg, New
Generation",
Art International, vol. VIII,
no. 4, pp. 51 - 54.

19
Quoted by Richard Cork,
David Bomberg, London:
Tate Gallery, 1988, p. 72.

David Bomberg
The Mud Bath
1914
Oil on canvas

The sense of relating to breaks in history, of minding a past history of vanguard art in Britain and of constructing a history of Modernism in London as being an instrumental guide for future strategies, was centred – for Denny – on the moment of Vorticism and the first wave of geometrical abstraction in 1914, which he intensively researched, returning to the theories of T E Hulme. Here had been another historical trench, a juncture with "English art struggling out of its straight jacket and entering an heroic phase…. I was fascinated by this grand and heroic moment." [17] The fact that David Bomberg's key paintings from 1912-1914 were on show in a retrospective at the Marlborough Gallery in early 1964 gave Denny his cue for a revisionist account which prioritised the pre-Great War abstractions – *In the Hold* and *The Mud Bath* – over the more canonical painterly expressionist versions of Bomberg. In his London Letter for *Art International* for May 1964 – "Bomberg, New Generation", he singled out *The Mud Bath* as "… a synthesis of form, tone, colour, space, flatness and depth and movement with an extraordinary economy of means… an entirely original work, and a prophetic one if we are looking for prophesy, invoking at the time a new kind of experience of the ambiguity of substance and space". [18] Bomberg's art of the immediately pre-Great War period was exemplary for the present: it was a precedent and support for Denny at a time when Pop figuration and softer-optioned colour abstractions were being promoted at the New Generation show. It had been the urbanist and abstract Bomberg who had written in 1914: "I look upon *Nature*, while I live in a *steel city*", and in 1964 the spring-legged abstract forms of David Bomberg, from *The Mudbath*, crossed over from the heroic time of Modernism, and took up residence as the formalised Atlantides in the portaled recesses in Denny's *Jones's Law* and *Secrets*, 1964. [19]

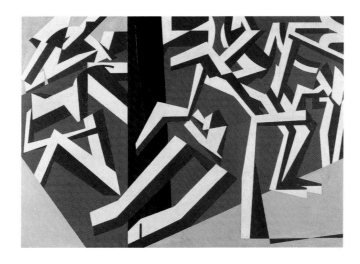

Church of Our Lady
of Lourdes, **Altar Reredos**
1975
London
Clive Broad & Partners,
commissioning architects.

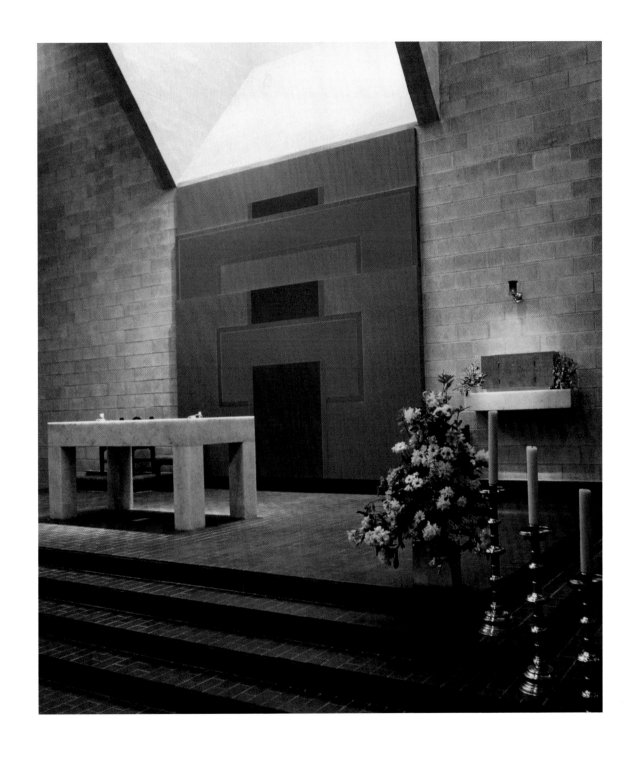

1
Soja, Edward,
"Post-Modern Geographies:
Taking Los Angeles Apart",
*Nowhere, Space, Time and
Modernity*, Roger Freidland
and Deidre Boden, eds.,
Berkeley: University of
California Press, 1994,
pp. 127 - 162.

2 & 3
Soja, "Post-Modern
Geographies: Taking
Los Angeles Apart",
pp. 132 & 133.

In Los Angeles, between 1981 and 1986, Denny found himself inhabiting and working in sites which stimulated him with their sense of irreducible difference; he was moving through the 'heterotopic' Los Angeles, in the sense which Edward Soja has defined the word.[1] Soja derived the term from Foucault, who projected a heterotopia as a place "… capable of juxtaposing in a single real space several spaces, several sites that are in themselves incompatible…".[2] Thus Denny's reverie which supposes *Tuscany with Palm Trees*, is located in front of the Hollywood Hills and introduces the old world as a kind of screen in front of the new world, also finds room alongside – in the LA series of imaginary, heterotopic, sites which he paints – *Pepsi Tokyo*, the "Little Tokyo" quarter in which he first had a studio.

4
Soja,
"Post-Modern Geographies:
Taking Los Angeles Apart",
p. 153.

5
For an architectural account
of the Indiana Avenue
Houses, a complex of which
Denny's studio was part, see
*The Architecture of Frank
Gehry*, Minneapolis: The
Walker Art Centre, 1986,
pp. 114 & 115.

We might observe that a crucial element in that culture shock for Denny of immersing himself in LA was the fusing of his own, highly developed notions of spatiality with this heterotopic universe. It was not for nothing that geographic references to local sub-cultures and predominating ethnic zones proliferate in his paintings in the 80s. To adopt Soja's use of Foucault's sketch of developing spaces in Modernist thought, Denny moved from the internal phenomenologies of Merleau Ponty to the variegated external sites and spaces of the heterocosmic, in his painted polychromed encryptions of LA's social life.[3] Denny's paintings montage this heterotopic culture as an array of evocative hybrid spatial and cultural nodes: *Pepsi Tokyo*, for example, refers to a precise location; a part ruinated, part convulsively modernised place, in Los Angeles: "… the compartmentalised corona of the Inner City… the Big Tokyo-financed modernisation of old Little Tokyo's still resisting remains".[4]

Denny moved studio and living space at least four times during his five years in Los Angeles. One studio where he worked for a year had been designed and built ten years before by the architect Frank Gehry. Its own spatialities were striking; a tall niche/*mihrab* structure in one corner, with a pointed top and one of those boxed narrow prosceniums which could have come from the set of *The Cabinet of Dr. Caligari*. In this studio Denny had found a secular but sacralised space of a highly wrought kind. On Indiana Avenue, Gehry's all-wood constructed studio had bullet holes in the windows and Denny was warned not to walk around the neighbourhood because it was a 'war-zone'. (In the light of Denny's fascination with the distressed and ruination, here was a site which was dangerously scarred and decayed – part of a then fashionable 'Post-Modern' sense of cultural ruination in the ambience of films such as William Freidkin's *To Live and Die in LA*.) The studio, which passed to Dennis Hopper after Denny's departure, had huge windows, letting in a brilliant light, geometrically patching together squared vignettes of the LA sprawl and palm trees outside. This is recorded in the remarkable photographs taken of Denny in the studio by Gehry's sister and friend of Denny, Doreen Nelson.[5]

Tuscany with Palm Trees

1984 - 1989

Acrylic on canvas

96 x 78 in

244 x 198 cm

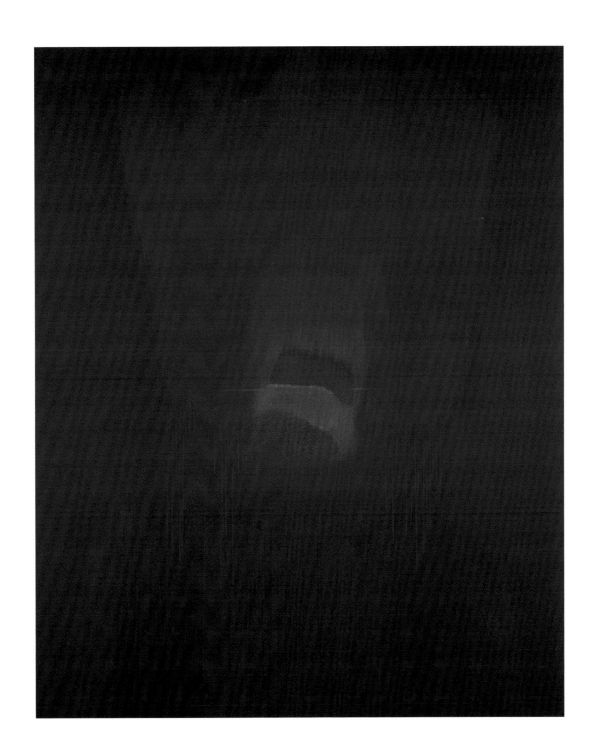

**Windward Steam
and Angel Dust**
1984 - 1987
Acrylic on canvas
96 x 78 in
244 x 198 cm

opposite
Razzle Dazzle
1984 - 1987
Acrylic on canvas
96 x 78 in
244 x 198 cm

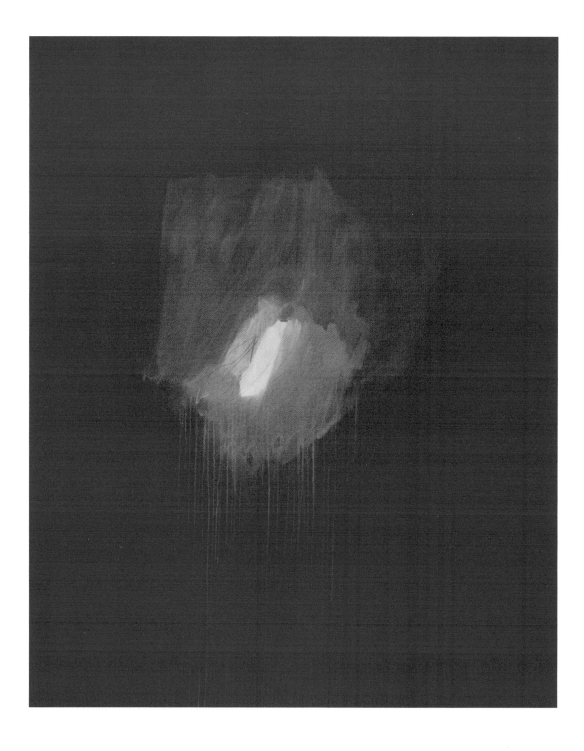

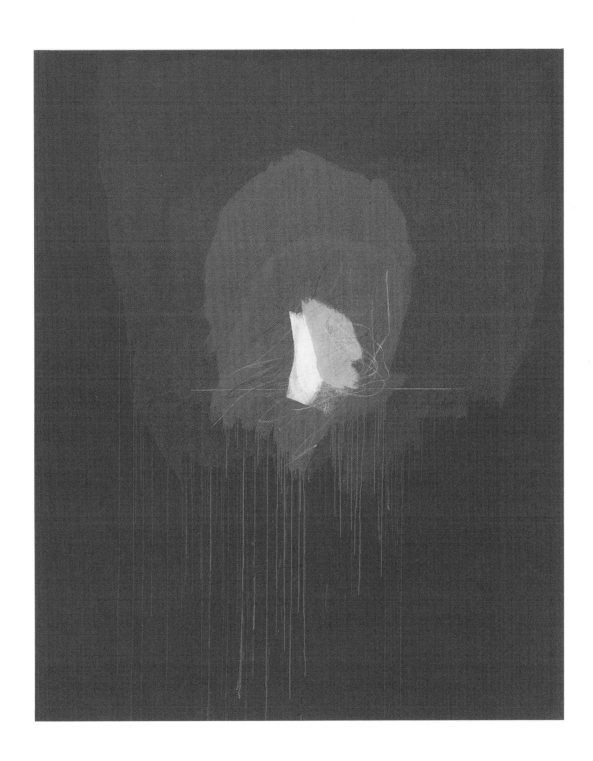

6

Vidler, Anthony,
"Wrap Session: the
Architecture of Frank Gehry",
Artforum, Summer 2001,
pp. 141-149.

7 & 8

Robyn Denny in
conversation with the
author, 26 October 2001,
London.

The 'aformal' – as a kind of aesthetic of freer, informal topologies – became paramount for Denny in his years in LA: Anthony Vidler has established this category to denote Frank Gehry's architectural language of "free-flowing and undulating surfaces… an indifference to the strategies and rules of academic composition".[6] The leaning, overlapping planes of Denny's enigmatic white volumes in *Sweet O'Zeeta*, 1985-1986 and *Razzle Dazzle*, 1984-1987 can be said to partake of this Gehry-esque new paradigm. The formal transformations attendant on morphing – a function of the new spatiality of digitisation – has been seen by Vidler as relating to Gehry's work, are similar to Denny's animated billowing, painted forms in LA. These shape shifters found in Denny's canvases of this period are like the fabulous creatures of the deepest ocean depths, generating their own light, inhabiting lustrous hyper spaces. Surfacing, flattened onto a larger screen, but still abyssal, flapping, like white sails, they are arguably part of the new cultural imagination affected by the digitisation of the visual in the 80s, from the epicentre of LA. These gauzy, billowing, white acrylic clouds, in *Performance*, *Razzle Dazzle*, *Sweet O'Zeeta* and *Windward Steam and Angel Dust*, give a pictorial lift – a kind of thermal effect animating an ephemeral gauze.

Primarily it was the Baudelairean artificiality of Los Angeles which he found intriguing. There was the aspect of "synthetic light" in particular: "… something so New World… the present is so assertive with an entirely synthetic light with internal connotations. I liked the smog, for example – because being an entirely synthetic light, the appearance and 'feel' of the city changed on a daily basis".[7] These urban transformations and the return of a spatially repressed depth from which the Real might emerge as a rent in the surface fabric of things, generated a fantastic hazing. An incorporeal mist rises up like an upward draft from the bottom of Denny's mid to late 80s paintings – in *Coca Tokyo*, in *Tuscany with Palm Trees*, in *Razzle Dazzle* and in *Windward, Steam and Angel Dust*; it bouys up allusions to Turner's Sublime. He had only nodded towards this Turnerian ineffable before, in the fogging and tonal misting of the later 60s paintings: then, from about 1982, Denny's painting enters into a state of pictorial crisis and becomes wholly figured by – and figuring in its turn – the indiscernible.

Easy
1985 - 1987
Acrylic on canvas
96 x 78 in
244 x 198 cm

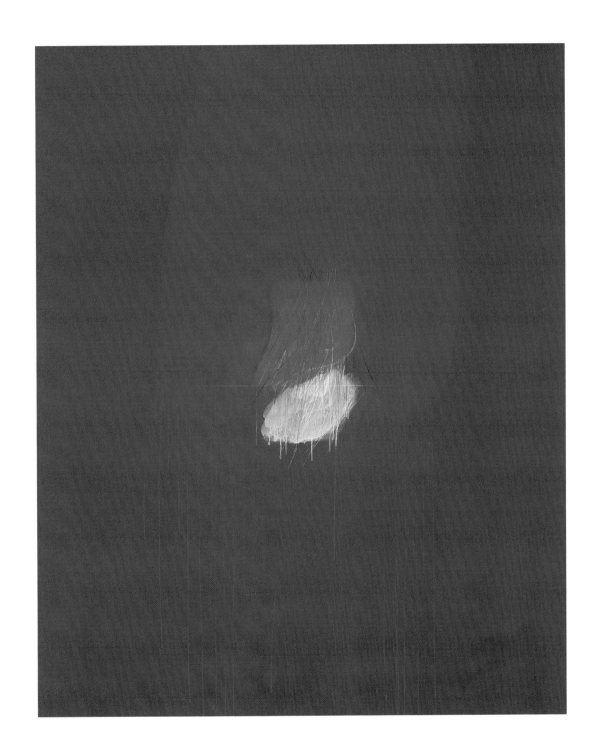

Performance

1984 - 1989
Acrylic on canvas
96 x 78 in
244 x 198 cm

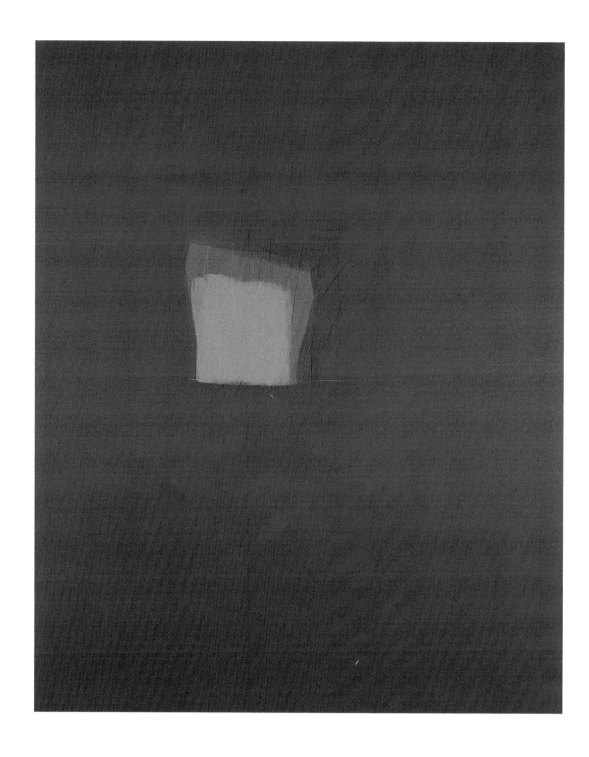

9
Wortz, Melinda,
"Robin Denny 'California
Paintings'",
Irvine: Fine Arts Gallery,
University of California,
May 1985, unpaginated.

J M W Turner
**The Sun of Venice
Going to Sea**
exhibited 1843
Oil on canvas

The Turnerian Denny: in his abyssal paintings from Los Angeles, in the mid 80s, Denny unfurled sails and sheets which seem to engage with some of the pictorial concerns of late Turner. He paraphrased the title of Turner's *Rain, Steam and Speed* in his own painting, *Windward Steam and Angel Dust*, which alluded to his own address in LA, on Windward Avenue, as well as the references to slang names of LA drugs of choice. So, "… the name of Turner comes up from time to time", and while Denny is at pains to emphasise his mediation and coding of places and atmospherics, he wished to avoid any kind of representationalism, in the sense that the paintings "… should not be seen as natural phenomena or events".[8] All the same, Denny himself cited Turner to Melinda Wortz in May 1985: "… there's always this feeling that if you scratch the surface of an English artist you'll find a landscape painter. We're all struggling with the ghost of Turner."[9] To struggle with the spectre of Turner is suggestive, and also may indicate an anxiety of influence. A reading of Turner refracted through Denny's art in Venice, California rather than Venice, Italy, would discover the mirage of Turner's painting, *The Sun of Venice Going to Sea* and that device of *mis-en-abyme* by which the ship's unfurled sail carries a smaller painting (of the sun, of efflorescent light) within Turner's canvas as a whole. Denny's paintings of the mid 80s, beginning in 1984, such as *Performance*, as much as the painting which openly advertises its adherence to a Turnerian field – *Windward Steam and Angel Dust*, are long and thoughtful meditations on Turner's lyrical colour paintings.

10

Rouve, Pierre, "Signs",
Art News and Review,
12 April 1958,
Robyn Denny Archive,
London.

11

Robyn Denny in
conversation with the
author, 19 July 2001.

The atmospheric colour veils; the 'struggle' with Turner; the pursuit of feeling and effect – all these elements point to Denny's links to a Symbolist frame of reference and meaning. The phantasmagoria of Denny's post 1982 work has unlooked for affinities with the pastels and oils of Odilon Redon, from nearly a century before. The ultramarine grounds, the grey-blues with breaking passages of light and cloud in landscapes of crags, and the juxtapositions of fragrant colourings with diffused points of light – and the fractious stone, the tears, producing a grotesque abstract, colouristic chiaroscuro, are points of comparison. It is in this respect that Denny's ascetic sublimities of scale and craggy effect match those of Redon, for example in paintings such as *Roger and Angelica*. 'Visionary' – before the Redon-esque promptings of *Moonshine* and the supernatural announcement of *Footlights 1*, and earlier, at the outset of his career – Denny's paintings were indeed associated with that Symbolist category of the visionary. In a review in April 1958, Pierre Rouve found the *Red Beats* series to be possessed: "Denny finds again that visionary power…. Once again, the beholder is drawn into that mysterious circle of his inner life where new universes spring… a zone of his own… the intuitive loading of the sign with a secret significance."[10] As the planes of tonal colour ebbed and leaked in the later 70s, his atmospheric light swelled, like a grand, universal form. (Or, topographically, stood at the end of the tunnel, or better, inhabited the speleological metaphor of Plato's version of the founding of representation, as in *My Blue Heaven*.) This blue-white light stands as a kind of binary opposite to the lurid red worlds of *Sweet O'Zeeta*, *Windward Steam and Angel Dust* and *Razzle Dazzle*.

Visionary light and the amorphous *informe* were important formal themes in the work of some of the LA artists he admired – Sam Francis, Robert Irwin, Larry Bell and Laddie John Dill, in his utilisation of neon and sand. James Turrell was another artist that Denny was interested in, in the 80s. (There may be some connection with Turrell's purity of lights and the boxy volumes of white primal illumination which rises from *Sweet O'Zeeta*.) Description of these informal forms becomes more complicated in the 90s, as his 80s atmospherics of paint veils gives way to the substantive physical dimensionalities and delicacies of the first relief paintings and drawings. Denny's aim was to offer up unnegotiable *informe* material, describing the paintings in their totalities as focus mechanisms centring enigmatic and obdurate coloured reliefs, textured like the limestone beds of Jurassic seas: "rectangles with a slab of stuff in the middle".[11] The ascendant white 'sail' over the impacted rose, in *Honey Trap*, gives a relief identity to the flaring white graffiti writing of the previous decade.

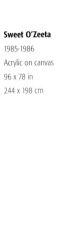

Sweet O'Zeeta
1985-1986
Acrylic on canvas
96 x 78 in
244 x 198 cm

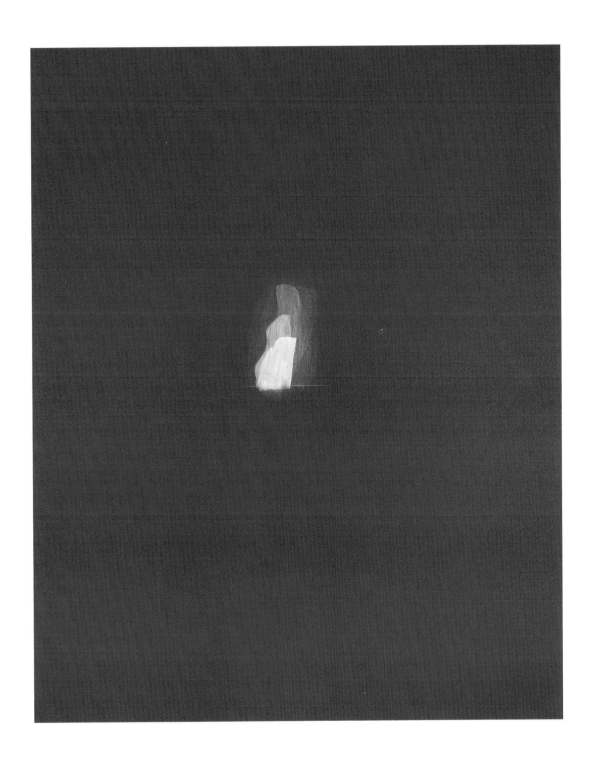

My Blue Heaven
1985 - 1986
Acrylic on canvas
96 x 78 in
244 x 198 cm

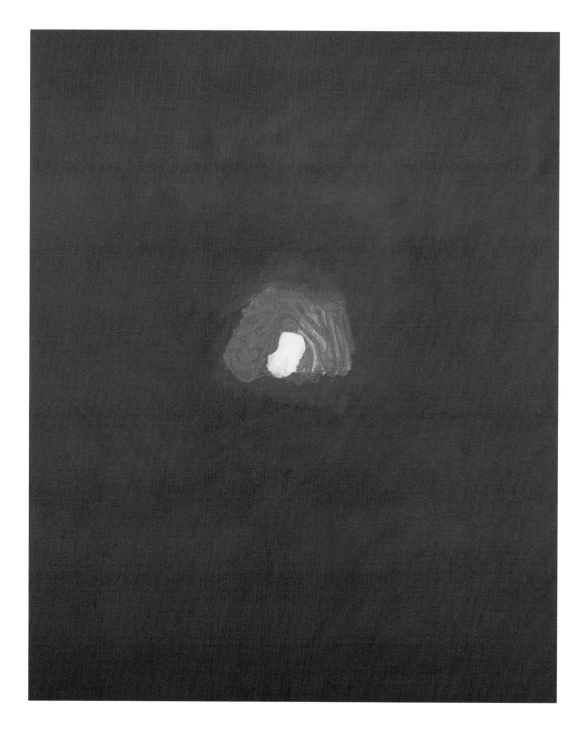

12
Barthes, Roland,
"The Wisdom of Art",
The Responsibility of Form,
Oxford: Blackwell, 1986,
pp. 176 - 194.

13
Krell, David Farrell,
Intimations of Immortality ,
Philadelphia, Penn State
Press, 1991, p. 58.

14
Blanchot, Maurice,
"Heraclitus", *The Infinite
Conversation,* Minneapolis:
Minnesota University Press,
1993, pp. 85 - 92.

Purple Passage
1991 - 1994
Acrylic on canvas
66 x 48 in
168 x 122 cm

There is a relationship between Denny's art in the 80s and that of Cy Twombly's paintings; just as there had been between Denny's work around 1960 and the painting of Ellsworth Kelly. One of Twombly's most acute commentators was Roland Barthes, who discovered two strategic techniques in his art: the scribble – Barthes refers to Twombly's "scriptory 'clumsiness'" and the *macula*.[12] Both these techniques have value for understanding Denny's post 1982 art, particularly the last. What Denny appears to do, with his cloudy stains, his *macula* – is similar to Twombly's clotting, but he reverses Twombly's dark clouds, they become pale and light and white. A linear white light becomes a primary signifier for Denny. In *Layline*, 1982, it crackled as a protracted epiphany, a scribble of secrets declared by lightning light. It is a catastrophic aspect of illumination, one that is never reflected, but internal, and it had already occurred in a series of diffused glows in his paintings of the mid 60s: those twilights, or nocturnes, which stand for some apocalyptic illumination. In *Layline*, the white emission line, while horizontal, should not be mistaken for the sign of a conventionalised horizon, a place of boundaries, or containment – the Greek *horismos*. Instead, Denny has broken with that kind of boundaried horizon, that world of demarcations which had fashioned his art up to that moment, and replaced it with an ecstatic space. David Farrell Krell has identified this ecstatic kind of horizon as present in Heidegger's thought in his Marburg lectures of 1927 and 1928 – not the *Umschluss* of containment, but the more original sense of a horizon as *Aufschluss*: "… the opening up of places and sites and possibilities in a world. Horizon is the open breadth. The rapture of temporalising temporality 'opens this horizon and keeps it open.'"[13] The piercing light in *Layline* precipitates an abrupt language of form and illumination on the thick and battered paper surface, equivalent to that "Lightning Speech" of Heraclitus' thunderbolt in his Ninth Fragment, a kind of white fire which consumes the thick painted air.[14]

Detail from a late
eighteenth / early nineteenth
century Suzuribako
(writing box).
Signed by Kanyosai.

Formalised as cartouches, spilt or spat out as cryptic ideograms, split-off from stone slabs, inscriptive signs – scratches, graffiti, dripping words, free lettering – all these entities zig-zag and circulate through and around Denny's art. An indication of these recursive signs is present in the leading illustration on the title page of Denny's Royal College of Art 1957 thesis, *Language, Symbol, Image*, of the Rosetta Stone, the key to ancient Egyptian language. The broken and irregular appearance of the stone, in its ruined rectilinear format, (like his slightly irregular stretchers pushing his paintings into polygons) which rises to a peak, has a formal similarity with those projecting relief 'stones' in his most recent work, such as *The Secret Life of Art*. In these the ghost of the Rosetta Stone's incised hieroglyphic, demotic and Greek writing loses its veridical value and becomes an enigma. Mediations of signs and their creation and manipulation is a thematic for Denny.

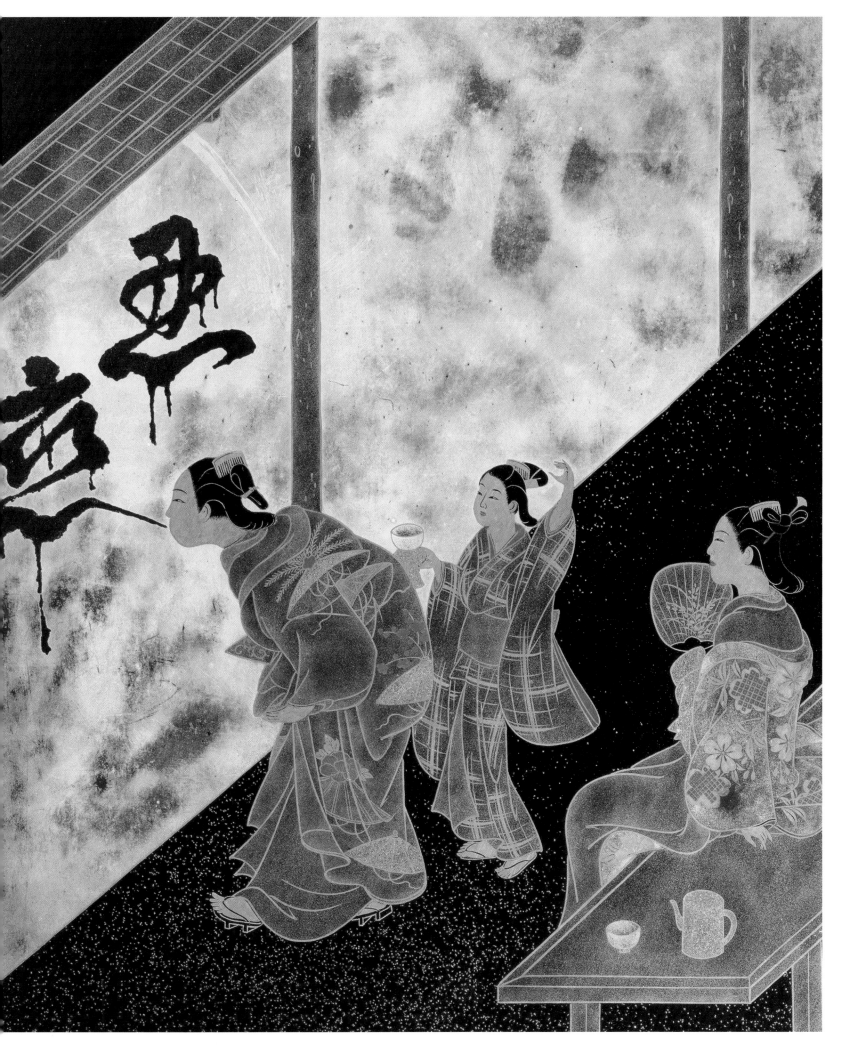

Writing

1

Kenner, Hugh, *The Pound Era*, London: Faber and Faber, 1975, p. 223.

Another of his RCA thesis illustrations imaged the ideogram in the visceral moment of its making. This was the import of Denny's use of a *Suzuribako* painting in 1957, and its re-appearance nearly 40 years later in *Love Wall*, 1991-1994.

The painting depicted a Japanese courtesan ejecting ink from her mouth, 'writing' in a convulsive, bodily manner. Roddy Maude-Roxby, a fellow student, had discovered this design from the Japanese Meiji period in the darkened corridors of the Victoria and Albert Museum, adjacent to the RCA, and pointed it out to Denny. It was on the surface of a *Suzuribako*, a lacquer writing box, a scene which had great iconographic circulation in Japanese culture, showing a courtesan and servant spitting ink on to an exterior wall in the dripping, informal graffiti form of the characters *shinobu koi* [secret love]. The box's indented ink stone and rimmed sub-divisions for brushes made up forms which have some links to the geometric compositional patterning of Denny's own oil paintings from the 1960s. In 1968 he completed a multiple in acrylic, *The Colour Box Series*, which had indented planified zones and compartments like those found in the *Suzuribako*. What Hugh Kenner, in his study of Ezra Pound's appropriations of Chinese and Japanese written ideogrammatic formats as techniques for the Anglo-Saxon Modernist moment of 1914, called "The Persistent East", only begins to designate this complex encounter and dialogue between a Western Modernism and the Eastern lineage of the ideogram.[1]

While preparing for this present monograph Denny wrote out a capitalised concrete poem composed of some of his titles from the 60s to the 90s, punctuated by slanting diagonal slashes. The poem began with "SECRETS/REMEMBER/FOREVER/…" – 'secrets'; which initiated an incantation of evocatory, unfolding and dissolving allusions, a lettered archipelago of secrets, bidden to remember, but riddled. Here is part of that Symbolist Denny of rising mists – almost Whistler – an Orientalism in the atmospherics of his Los Angeles paintings and their rising vapours and atomised liquids, such as the evanescent *Pepsi Tokyo* series. More apt an allusion in this context – of the scriptory and writing – is the Mallarme-esque Denny, the writer of desire as carefully articulated and self-reflexive cells which are formally disposed across the void of a screen, disclosing an awareness of the edges and frame of paper's or canvas' edge. A writing master, like the one who, in Japan, had owned the writing box whose design Denny had turned to.

SECRETS/REMEMBER/FOREVER/TOGETHER/ONE DAY/A TIME/AND THEN/
A SENSE OF OCCASION/SLOW HAND/BETWEEN OURSELVES/SEEING THINGS/
THINKING OF ENGLAND/SWEET O'ZEETA/WINDWARD STEAM AND ANGEL DUST/
GOTHIC-A-GO-GO/RAZZLE DAZZLE/OH! QUEL CULTURE/PASSION SPENT/
PEPSI TOKYO/AERIAL P./APPLE PASSAGE/HONEY TRAP/
MISC.CYN./KISSKISS/LOVE WALL/LOW LIFE/
SONGS/SHADOWS/GHOSTS/& GLORY IN THE AIR/THE ART OF ROBYN DENNY/

Love Wall

1991 - 1994
Acrylic on canvas
66 x 48 in
168 x 122 cm

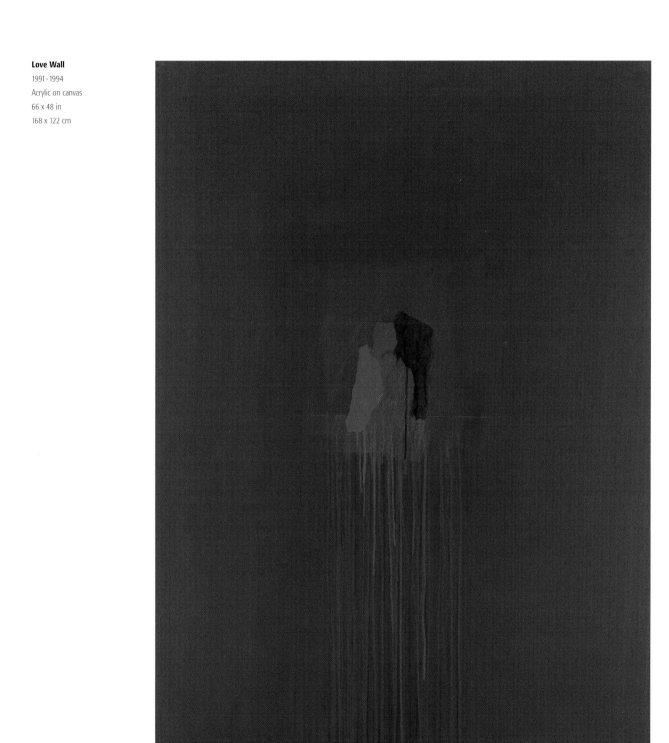

Writing

Eden Come Home
1957
Bitumen and gold size
on board
48 x 96 in
122 x 244 cm

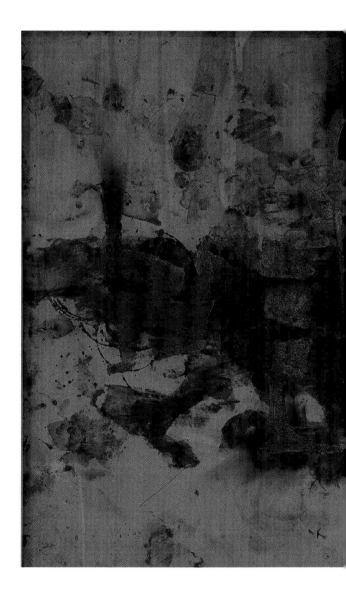

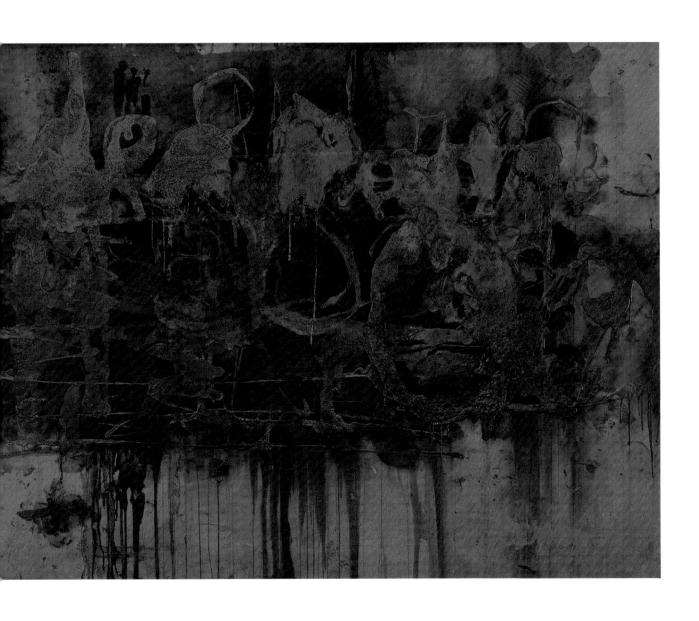

Writing

Hand-printed poster for
discussion at the Royal
College of Art, 1957.

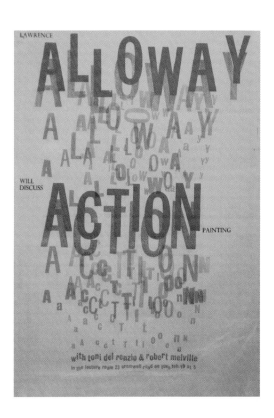

2
Rouve, Pierre, "Signs",
Art News and Review,
12 April 1958, Robyn Denny
Archive, London.

3
Kahnweiler, Daniel Henry,
Klee, Paris: Les Editions
Braun et Cie, 1951.

4
Rouve, "Signs".

Word Row
1957
Paper/pigment on card
8 ½ x 9 ½ in
22 x 24 cm

Writing and the deployment of painterly and montage treatments of typography had been crucial to Denny's formation. In 1958 Pierre Rouve had found a secret intimacy of the imagination active in Denny's typographic works, possessing more poetry than the 'mastodonic' action painting, *Wideaway*, or the collages which Denny was showing at Gimpel Fils in London. The 'visionaryness' of Denny may have as much to do with his manipulation of impure, relief, montaged and typographic forms of expression as the Sublime hovering gateways to otherness and disembodied monadic powers of the 60s. *Alice in Wonderland* was alluded to by Rouve in terms of the play of language, through Denny's agrammaticality and typographic euphoria, seven years before his Carrollian painting *Drink Me*, 1965: "… these signs have become the letters of a personal alphabet which has nothing to do with the one we learned in our teens. It is the alphabet with which Robyn Denny writes the memoirs of a painter in Wonderland." [2] Denny had been gifted a volume of reproductions of Paul Klee, in Paris in 1951, by Kenneth Noland's brother, Neil, then a fellow student at the Academie de la Grande Chaumiere. [3] Klee's typographic and word experiments, together with his sombre colourings in his runic paintings of the later 30s, might be seen in relation to the *XXS* series. The powers of Klee's influence were manifest, Rouve believed, in paintings such as *Funny Face*: "It may be true that Denny's work is an echo of Klee's *Villa R*, in a forest of non-geometrical lines. But from this double start of extreme refinement and equally extreme spontaneity, Robyn Denny has progressed into a zone of his own." [4]

5
MacLeod, Glenn,
"The Visual Arts",
*The Cambridge Companion
to Modernism,* Michael
Levenson ed., Cambridge:
Cambridge University Press,
1999, p. 207.

6
Smith, Richard, "Ideograms",
Ark, no. 16, pp. 52-56.

7
Tashjian, Dickran,
Skyscraper Primitives,
Cincinatti: Wesleyan
University Press, 1975,
pp. 165-187.

Cover of the Royal College
of Art thesis **Language,
Symbol, Image**, 1957.

Between words and pictorial sign lay this zone of Modernism which contained immense productivity for Denny. When he was working in Paris at the beginning of the 50s, Neil Noland introduced him not only to Paul Klee but also to the poetry of e e cummings, who had "always considered himself 'poetandpainter'", and cummings' syntax and strategies of writing fomented Denny's interdisciplinary approaches to language and visuality which he then developed in his RCA thesis.[5] The textualising of painting was becoming a significant issue in the pages of the RCA magazine, *Ark*, in the second half of the 50s and agendas around the typographic image and collage, in their return to Modernist vanguardism, were evident. Richard Smith's 1956 essay, "Ideograms", sought the sanction of the founding fathers of vanguardism – proclaiming, "… word and image are one", from Hugo Ball, as superscription to the article. Marinetti's 'words in freedom', Mallarme's poetry and Apollinaire's *calligrammes* also appeared, as did cummings' free verse.[6] e e cummings' use of experimental typography in the early 20s has been traced by Dickran Tashjian, who has described a "rampant typography" whose aim was typographical play as a ludic area of scriptive practice, which embraced Mallarme and Rimbaud, alongside the efforts of van Doesburg, whose aims were the placing of various scriptive forms at the disposal of a synaesthetic, pan-visual Modernism.[7]

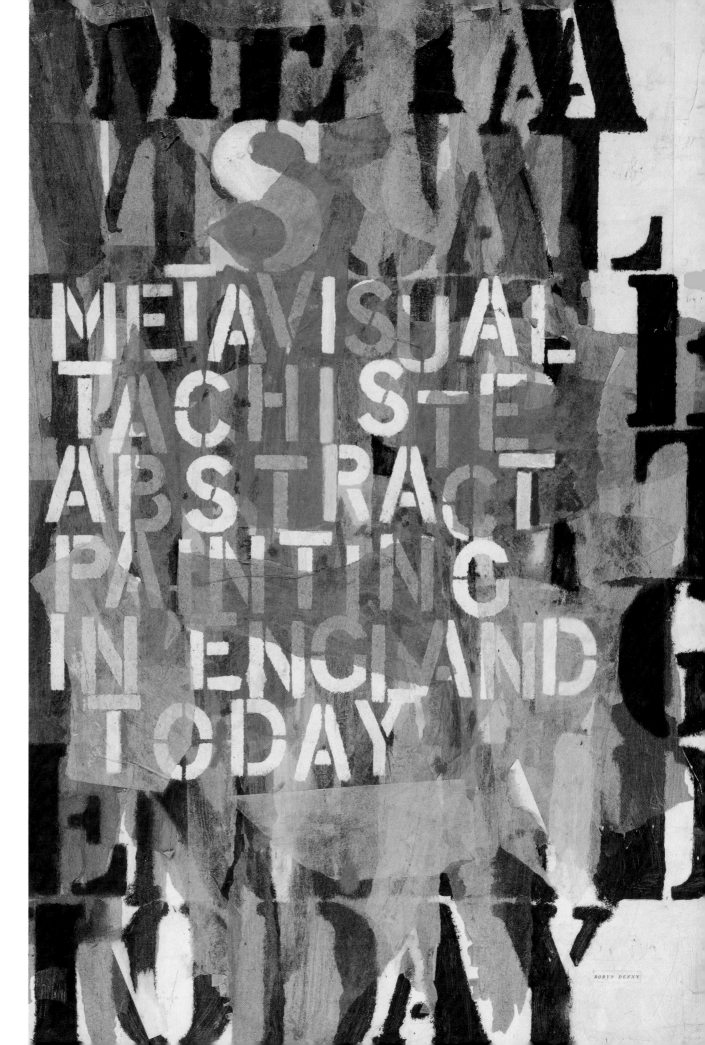

Hand-printed poster for
exhibition at Redfern Gallery,
London, April 1957.

8
Tashjian, *Skyscraper Primitives*, p. 178.

9
For a description of agrammaticality at work as a function of Modernist writing, see Deleuze, Gilles, "Bartleby: or The Formula", *Essays Critical and Clinical* 1998, London: Verso, pp. 68 - 90.

10
Peter Halley, Lecture, Tate Modern, 20 October 2001.

Peter Halley
The Deep End, 2001
Acrylic, Day-Glo and pearlescent acrylic, and Roll-a-Tex on canvas
89 x 81 in
226 x 206 cm

In the early 20s cummings was using upper case and lower case lettering, and running words together, as well as arbitrarily dividing them with a disjunctive syntax, in ways which Denny may have had in mind when he made posters, montages and finally the *Austin Reed Mural* and the *Abbey Wood Mosaic*. Tashjian lights upon a central formal metaphor in cummings poetry, that of confetti; "… the descending motion of which is reflected by the visual movements of words… a verbal abstraction for the sake of visual concreteness".[8] Here are the gravitational vectors which are so crucial to Denny – the rising and falling to the floor; the epiphanic ascension and elegiac return of light particles as signs – of *Glory in the Air*. Like Denny, cummings appears as an embodied social actor of Modernity, expressing an erotic and sensuous vitality, an urbanism and an urbanity and a satirical bent which could voice: *Oh! Quel Culture*. Perhaps it was the agrammaticality of e e cummings which Denny best put to use in the expostulations of *Funny Face* and the *Austin Reed Mural*.[9] Behind cummings' influence on Denny stood Pound and the interdisciplinary aspects of the Imagism and Vorticism of 1912-1914, that potent zone of inscriptive ferment to which Denny had returned in his research around T E Hulme and Bomberg in 1964.

Peter Halley – whose paintings appear as reified versions of Denny's high 60s style – has made a claim for abstract art being enmeshed in a world of non-tangible forms and processes, such as computers or telephone systems. Fundamentally, he has said; "Abstraction should be linked to linguistics, not so much the interplay of forms so much as the interplay of signs, which have no inherent meaning. Our world is emphatically governed by linguistics…. Geometric abstraction is re-surfacing, often having to do with the place of computers in our lives…."[10] Denny has, we could say, worked in this register – that of the technotronic sign – from as early as 1958, fascinated by the imagery promoting telecommunications, when he collected material from Olivetti covering digital data transmission. Here the designs found by him on Olivetti's promotional brochures acted as illustrations of an invisible technical mediascape, of cascading numbers and bits of information, in a confetti-like, cummings-like format which may have influenced his design for the RCA poster advertising Lawrence Alloway's "Action Painting" lecture and symposium. This cascade of signs is found as much in the great letter paintings and montages of 1956-1959, as in the falling grey drips of *Love Wall*, 40 years later.

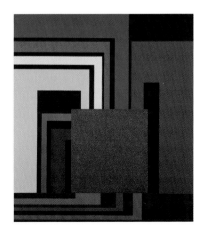

Red Beat 6

1958
Oil on board
48 x 72 in
122 x 183 cm

Little Man

1964 - 1965
Oil on canvas
84 x 72 in
213.5 x 183 cm

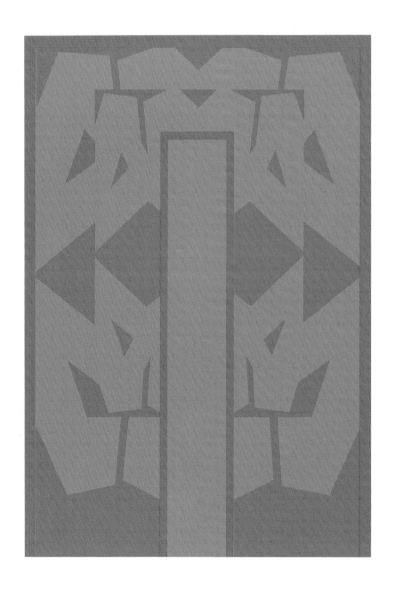

11

Jones, Owen, *The Grammar of Ornament*, 1856, p. 66.

Linear, scriptive and incised signs moved, were shifted by gravity or could be recomposed as decoration. The historical forms of decoration surveyed and archived in Owen Jones' 1856 *The Grammar of Ornament*, as well as the tabular, sampled and displayed, formats presenting them, had an influence on Denny. He discovered this great Victorian reference work while still a teacher at the Bath Academy at Corsham Court, in the early 60s. The gathered archived plates, mustering examples in a rationalised, rectangular grid, with stepped assemblages, haunt Denny's compositions: they become plates with ornamental samples laid out upon them – even something like his 1968 design for the Paramount Cinema *Acoustic Mural* was organised of elements in a mode of display which was only partially scenic. Owen's influence on Denny is most evident in Plate XXXIX of *The Grammar of Ornament*, "Mauresque No. 1". Here interlaced designs from the Alhambra were enshrined as paradigms of a global standard of decoration, the "… very summit of perfection of Moorish art, as is the Parthenon of Greek art…. Every principle which we can derive from the study of the ornamental art of any other people is not only ever present here, but was by the Moors more universally and truly obeyed".[11] Denny refers to this summit of world art in his 1963 painting, *Hall of the Ambassadors*, the building within the Alhambra complex from which many of Jones' motifs are taken.

Me, Myself and I (1)
1999 - 2002
Acrylic and mixed-media
on board
88 ½ x 72 in
225 x 183 cm

opposite
Me, Myself and I (2)
1999 - 2002
Acrylic and mixed-media
on board
88 ½ x 72 in
225 x 183 cm

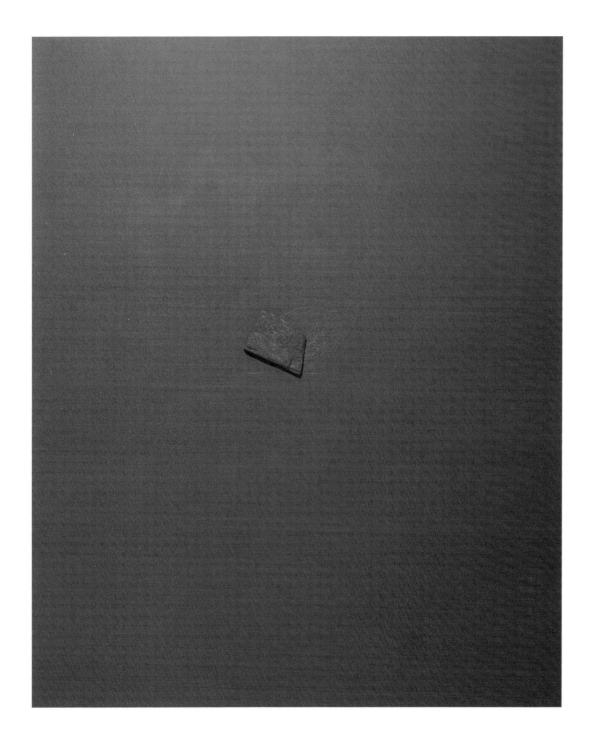

Writing

12

Jones, *Grammar of
Ornament*, p. 66.

13

Robyn Denny in
conversation with the
author, 20 December 2001.

Denny's interest in writing as a form of pictographic production may have been supported by Jones' argument that the absence of symbols in these decorations is more than made up for by ideogrammatic forms. The 'abstract' decorations are, crucially, supplemented by writing. Jones points out: "… inscriptions, which addressing themselves to the eye by their outward beauty, at once excited the intellect by the difficulties of deciphering their curious and complex involutions, and delighted the imagination when read, by the beauty of the sentiments they expressed and the music of their composition".[12] Thus Denny might have constructed these designs, and the 'asymmetric' compositions of 1964-1965, as forms of inscription. For Denny, what Jones' plates, especially Plate XXXIX, revealed, in their surface twists, their coruscations and disappearances in their intertwinings, was the presence of secrets – that category which remains a touchstone for him in his building of abstract paintings. In the *XXS* series and other of his asymmetric paintings of 1964-1965, he said that he had "… blocked out bits – the secrets, the underlife… so that what you see is the continuous life of the line".[13] Denny's early 1960s reading of the Islamic parts of Owen Jones's *Grammar of Ornament*, like Paul Nash's uncanny Surrealist reading of Sir Thomas Browne's *The Garden of Cyrus or The Quincunx* in the 30s, suggests associations with repressed and cryptic but paradisal Eastern geometries within English culture. The colour and look of the enamels which he made for St Thomas' Hospital, in London, in 1974, also have strong homologies with Jones' figuring of orthostatic realms and with Islamic mosaics and decorations.

"Torn symmetries" might be the phrase to describe the shift in his art from the 1970s to the 80s. Tears and rents appeared in the paper drawings which he began in the 70s, in a series collectively called *Moody Blues*, which he had set aside and then returned to in the 90s, which were first seen in 2001. Folded coloured paper glyphs, teased out into splayed and gravitationally oriented formations (like the cravat-like feature in the recent works such as *Footlights 1* and *Footlights 2*); Constructivist card tabs, saturated in colour, and, like Caro's flattened scenographic sculptures of about 1961, they coalesce into horizon hugging cluster forms; or Guston's abstract humps. *En abyme*, as painted surfaces within paintings, in their framed state of coalesced painting, they seem to bloom outwards, complexly yet flat, splayed like exotic leaves, while remaining centred on a monochrome blue or red field. The cornets of paper which animate *Moody Blues* are abstract cartouches, and as cartouches they have a direct association with the format of Egyptian hieroglyphics, which contained and compressed significant glyphs within a boundary. These resonances of broken stone spill far from associations with the Rosetta Stone, when the chalky outcrops of *Shadows 2* and *Me, Myself and I* are examined. The rending and splitting lines of these asymmetric associations might go as far as the tablets of The Law, of the Ten Commandments. But according to Denny's recent painting reliefs, the summit of the interpreter's and lawgiver's stones have become broken by eruptions of further, endless secret lines and the implacable Real, and language has returned to nature, worn down while projecting into seas of painted red and white.

1
Royal College of Art, London, 1956-1957

2
Studio at Vernon Yard, Portobello Road, London, 1961

3
33rd Biennale, Venice, 1966

4
Milan, 1968

5
Kasmin Gallery, London, 1969

6
Kasmin Gallery, London, 1971

7 & 8
Studio at Francis Wharf, London, 1973

Solo Exhibitions

1958
Gallery One, London
Gimpel Fils, London

1961
Molton Gallery, London

1962
Galleria Scacchi Gracco, Milan

1963
Galerie Muller, Stuttgart

1964
Kasmin Gallery, London

1966
Robert Elkon Gallery, New York

1967
Kasmin Gallery, London
Robert Elkon Gallery, New York

1968
Renee Ziegler, Zurich
Forum Stadtpart, Graz

1969
Kasmin Gallery, London
Waddington Gallery, London
Arnolfini Gallery, Bristol

1970
Galerie Muller, Stuttgart & Cologne
Robert Elkon Gallery, New York

1971
Arnolfini Gallery, Bristol
Kasmin Gallery, London

1972
Galerie Ziegler, Geneva

1973
Tate Gallery (retrospective exhibition), London
Wurttenbergischer Kunstverein (retrospective exhibition)
 Stuttgart
Stadtisches Museum (retrospective exhibition), Leverkusen
Studio La Citta, Verona
Galerie T, Amsterdam

1974
Marlborough Gallery, Rome
Galleria del Cavillino, Venice
Galleria L'Approdo, Turin
Galleria Rondanini, Rome
Galerie Wentzel, Hamburg
Galerie Wellman, Dusseldorf
Santiveri Gallery, Paris
Galerie Jacomo-Sontiveri, Paris

1975
Galleria La Polena, Genoa
Jacques Damase Gallery, Brussels
Neue Galerie, Linz
Galerie Modulo, Porto

1976
Galleria Morone, Milan

1977
Waddington and Tooth Galleries, London

1978
Festival Gallery, Bath

1979
Bernard Jacobson Ltd, London
Bernard Jacobson Ltd, New York

1980
Aronson Gallery, Atlanta

1981
Jacobson/Hockman Gallery, New York

1982
Bernard Jacobson Gallery, Los Angeles

1985
Fine Arts Gallery, UC Irvine, Irvine, California

1992
Bernard Jacobson Gallery, London

2001
Hirschl Contemporary Art, London

2002
Hirschl Contemporary Art, London

5

Group Exhibitions

1953
Young Contemporaries, RBA Galleries, London

1954
Young Contemporaries, RBA Galleries, London

1956
Young Contemporaries, RBA Galleries, London

1957
Young Contemporaries, RBA Galleries, London
Summer Exhibition, Redfern Gallery, London
Pictures Without Paint, AIA Gallery, London
Six Young Contemporaries, Gimpel Fils, London
Metavisual, Tachiste, Abstract, Redfern Gallery, London
Critics Choice, (Nevile Wallis) Arthur Tooth & Sons, London
Dimensions, O'Hana Gallery, London
Summer Exhibition, Gimpel Fils, London
Metavisual, Tachiste, Abstract, Musee des Beaux Arts, Liege
First Exhibition of Contemporary Paintings, Ana Berry
 Memorial Fund, White House, Haverstock Hill, London
The British School at Rome, Imperial Institute, London
British Abstract Art, Brussels and Dusseldorf
New Trends in British Art, New York Art Foundation, Rome

1958
London Group, RBA Galleries, London
A1A25, RBA Galleries, London
Summer Exhibition, Redfern Gallery, London
Robyn Denny and Charles Carey, Gallery One, London
American Guggenheim Awards, Manchester City Art Gallery
American Guggenheim Awards, Whitechapel Art Gallery,
 London
American Guggenheim Awards, Brighton Art Gallery
Drawings of Contemporary British Artists, Aldeburgh
 Festival, UK
Contemporary Art Acquisitions, Albright-Knox Art
 Gallery, Buffalo
British Painting, Neiman Marcus, Dallas
British Abstract Painting, Auckland City Art Gallery
British Abstract Painting, National Gallery of Art, Sydney

1958 - 59
British Painting, Smithsonian Institute, Washington DC
(Touring) Gravures en Couleurs, Redfern Gallery, London

1959
London Group, RBA Galleries, London
Annual Picture Fair, ICA, London
Six from Now, Cambridge
Exhibition of Contemporary Painting, City Art Gallery, Carlisle
British Paintings and Prints from Paris Biennale,
 AIA Gallery, London
Premier Biennale, Musee D'art Moderne, Paris
Premio Lissone, Milan

1959 - 60
John Moores, Liverpool Exhibition, Walker Art Gallery,
 Liverpool

1960
Situation, RBA Galleries, London
Danad Design, Portal Gallery, London

1960 - 61
Six Young Painters, Arts Council Tour, UK

1961
Print Fair, Redfern Gallery, London
Directions-Connections, AIA Gallery, London
Art of Assemblage, Museum of Modern Art, New York
New London Situation, New London Gallery, London
Neue Marlerie in England, Stadtches Museum, Leverkusen
Aspects of Collage, Brook Street Gallery, London

1962
Denny/Gredinger/Olsen, Galerie Handschin, Basel
Nine Painters from England, Galleria Trastevere, Rome
Towards Art, Royal College of Art, London

6

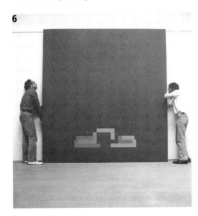

1962 - 63
Situation, Arts Council Touring Exhibition, (Cambridge,
 Aberdeen, Newcastle-upon-Tyne, Bradford, Kettering and
 Liverpool)

1963
British Painting in the 60s, Tate Gallery, London
Whitechapel Art Gallery, London
Absolute Farbe, Avant Garde 63 Museum, Trier
Towards Art, Arts Council, Touring Exhibition
7 Junge Englische Male, Kusthalle, Basle, Galerie Huber,
 Zurich
Ten Years, Gallery One, London
H 63, Hamilton Galleries, London
7th International Biennale, Tokyo

7

1964
John Moores Liverpool Exhibition, Walker Art Gallery,
 Liverpool
ICA Screenprint Project, ICA, London
Documenta 111, Kassel
Sammlung 'La Peau de L'ours', Kunsthalle, Basel
12 Signierte Originalgraphike, Galerie Muller, Stuttgart
Young British Painters, 1955 - 1960, Art Gallery of
 New South Wales, Sydney
Contemporary British Painting and Sculpture,
 Albright-Knox Art Gallery, Buffalo
Britische Malerei der Generwart, Kunsthalle, Dusseldorf

1965
New Painting 1961-1965, Arts Council Touring Exhibition
 (1965-66)
Graphics in the Sixties, Editions Alecto, London
Graphics in the Sixties, RWS Galleries, London
Trends in Contemporary British Painting, Bear Lane Gallery,
 Oxford
Print Fair, ICA, London
View Point, Corsham Painters, Bath Festival
London: The New Scene, Walker Art Gallery, Liverpool
 Minneapolis - USA and Canadian Tour
Paris Biennale, Musee D'Art Moderne, Paris
Signale, Studio F, Ulm
Arnolfini Gallery Show, Bristol
Focus on Drawing, Art Gallery of Toronto
Art Vivant, Foundation Maeght, Paris

1965 - 66
John Moores, Liverpool Exhibition, Walker Art Gallery,
 Liverpool

1966
Prints at Manchester, Manchester City Art Gallery
Exhibition of Living Art, College of Art, Dublin
How they Started, Oxford University
Robyn Denny/John Ernest, Arnolfini Gallery, Bristol
Caro/Cohen/Denny/Smith, Kasmin Gallery, London
Four Englishmen, Galleria Dell 'Ariete, Milan
33rd Biennale, Venice
5 Junge Englander, Kunsthalle, Mannheim, Biennale
 Venedig
International Print Biennale, National Museum of
 Modern Art, Tokyo

1967
Vormen van de Kleur, Stedelijk Museum, Amsterdam
Summer Group, Robert Fraser Gallery, London
Qualifying RCA Diploma Paintings, Graves Art Gallery
 Sheffield
1st Edinburgh open 100 exhibitions, The David Hume
 Tower, Edinburgh
Recent British Painting, Stuyvesant Foundation, Tate Gallery
 London
Exposition Internationale de Gravures, Vancouver
Formen der Farbe, Kunstverein, Stuttgart
Formen der Farbe, Kunsthalle, Berne
Recent Prints from Britain, Auckland City Art Gallery
Four British Painters, Two British Potters, Museum
 Boymans - van Beuningen, Rotterdam
7th Esposition Internationale, Modern Galeria, Ljubljana
Jeunes Peintres Anglais, Palais des Beaux Arts, Brussels
Four Young English Painters, Kunsthalle, Mannheim
Jeunes Peintres Anglais, Galerie Alice Pauli, Lausanne
Jeunes Peintres Anglais, Galerie Feigel, Basel

1967 - 68
John Moores Liverpool Exhibition, Walker Art Gallery
 Liverpool
Carnegie Institute, Pittsburgh International, Pittsburgh

1967 - 69
Arts Council Touring Exhibition, New Prints 4

8

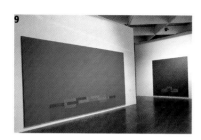

1968
A Collector's Exhibition, Winnipeg Art Gallery
Recent British Painting, Manchester City Art Gallery
Purchases, The Contemporary Art Society, Whitechapel Art
 Gallery, London
25 Senior St. Martin's Students, Zwemmer Gallery, London
25th Camden Festival Exhibition, London
Works on Paper, Waddington Gallery, London
Ceri Richards/Robyn Denny, Art Centre, Bristol
New Prints, Hull Regional College of Art
Prints, Sussex University
British Printmakers, Stockholm
10th International Exhibition of Drawings and Engravings -
 Bianco e Nero, Lugano
Arte Moltiplicate, Galleria Milano
Suites, Recent Prints, Jewish Museum, New York
Junge Generation, Grossbritannien, Akademie der Kunste,
 Berlin
Prospect 68, Dusseldorf
Mostra Mercato d'art Contemporanea, Palazzo Strozzi,
 Florence
Ornamentale Tendenzen, Berlin
Ornamentale Tendenzen, Leverkusen
Ornamentale Tendenzen, Schloss Wolfsburg
Peintres Europeans d'Aujourd'hui, Musee des Arts
 Decoratifs, Paris and USA Tour
Art Vivant, Foundation Maeght, Paris
International Grafik, Oldenburg; Bremerhaven;
 Willemshaven

1968-69
First International Print Biennale, Cartwright Memorial Hall,
 Bradford

1968-70
Painting 64-67, Arts Council Tour

1969
Stage 1, Alecto Gallery, London
Exhibition of Alectco Colour Boxes, Gimpel and
 Weitzenhoffer, New York
First International Print Biennale, Liege, Belgium
Contemporary British Paintings, South African Tour
Kasmin Artists, Arts Council Gallery, Belfast
New Editions, Museum of Modern Art, Oxford
Prints, Durham and Bradford Universities
Lithographs and Screenprints, Walker Art Gallery, Liverpool

Eighth International Exhibition of Graphic Art, Ljubljana
12 Britische Artisten, Kunstlerhaus Galerie, Vienna
Contemporary British Painting, Art Centre, Delaware

1970
Arts Council Touring Exhibition (New Prints)
Kelpra Prints, Hayward Gallery, London
Contemporary British Art, National Museum of Modern Art,
 Tokyo
British Painting and Sculpture 1960-70,
 National Gallery of Art, Washington DC

1970-72
Large Paintings, Arts Council Touring Exhibition

1971
Galerie Mikro, Berlin
Galerie Muller, Cologne

1972
14 Big Prints, Waddington Galleries 11, London
Alecto International, Studio La Citta, Verona

1974
Musee d'art et de Histoire Cabinet des Estampes, Geneva
Galerie Schottinring, Vienna

1975
Peinture Anglaise Contemporaine, Musee de Grenoble
La Pitture Inglese Oggi, Ciak Gallery, Rome

1976
For John Constable, Tate Gallery, London
Arte Inglese Oggi, British Council Show, Milan
Grafica 76, Kentucky University
For John Constable, Galerie Yves Brun
Peintres et Sculpteurs Britanniques, Centre Culturel
 de la Ville de Toulouse

1977
Annual Show, Hayward Gallery, London
Jubilee Exhibition, Royal Academy, London

1979
The Museum of Drawers, Kunstmuseum, Bern
The Deck of Cards, J P L Fine Arts, London
New Editions from England, Bernard Jacobson Gallery,
 New York
20th Century British Art, Middlesbrough Art Gallery

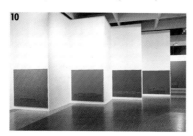

1980
Gallery Artists, Bernard Jacobson Ltd., London
Kelpra Studio - The Rose and Chris Prater Exhibition,
 Tate Gallery, London
New Publications, Bernard Jacobson Gallery, London

1981
Salty Le Gallais Gallery, Jersey, Channel Islands
Groups 1V, Waddington Galleries, London
Recent Drawings, Jacobson/Hochman Gallery, New York
Artlaw Exhibition and Auction, Royal Academy Diploma
 Galleries, London
100 in 1, Group Exhibition, Studio La Citta, Verona
Prints by Six British Painters, Tate Gallery, London

1982
Drawing - New Directions, Summit Art Gallery
 Summit, USA

1983
The Granada Collection, Whitworth Art Gallery, Manchester
The London Suite (Prints), Ikon Gallery, Birmingham

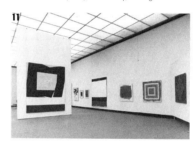

1984
Home and Abroad, Arts Council Exhibition,
 The Serpentine Gallery, London
Art Within Reach, Ikon Gallery, Birmingham
Printmakers at the Royal College of Art, Barbican Art
 Gallery, London

1985
Twenty Five Years, Annely Juda, London

1987
Anniversary Exhibition - Printmaking from the RCA Centre,
 London

1988
Exhibition Road, Painting at the Royal College
 of Art, Royal College of Art Gallery, London
Corsham - A Celebration, Michael Parkin Gallery, London
The Presence of Painting, Aspects of British Abstraction
 1957-1988, Mappin Art Gallery, Sheffield

1989
Corsham - A Celebration, Victoria Art Gallery, Bath
The Presence of Painting, Ikon Gallery, Birmingham
The Presence of Painting, Hatton Gallery,
 Newcastle Upon Tyne

1990
The Day Book Pictures, Smiths Gallery, London and Tour

1991
The Discerning Eye, The Mall Galleries, London
 and The Williamson Gallery, Birkenhead
Small is Beautiful - Abstacts, Flowers East, London
Cabinet Paintings, Hove Museum and Art Gallery and
 The Glynn Vivian Art Gallery and Museum, Swansea
Not Pop, What the others were doing, Bernard Jacobson
 Gallery, London

1992
The New Patrons, Twentieth Century Art from Corporate
 Collections, Christie's, London
Ready Steady Go, Painting from the Sixties, from the
 Arts Council Collection, The South Bank Centre,
 London
Three Artists Three Decades, Robyn Denny, John Hoyland,
 Gwyther Irwin, Redfern Gallery, London

1993-94
The Sixties Art Scene in London, Barbican Art Centre,
 London
British Abstract Art, Painting, Flowers East, London
British Art in the Sixties, England & Co, London
Small is Beautiful - Homage, Flowers East, London

1995-96
Out of Order, Independent Art Space, London
The Drawing Show, Bernard Jacobson Gallery, London
British Abstract Art, Drawings. Flowers East, London
Really Out of Order, Hansard Gallery, Southampton

2002
Transition; The London Art Scene in the 50s, Barbican
 Art Centre, London

13

Public Collections

Tate Gallery, London
Victoria and Albert Museum, London
Arts Council of England
The British Council
Contemporary Art Society, UK
Government Art Collection, UK
Department of the Environment, UK
Granada Art Collection, UK
Peter Stuyvesant Collection, UK
Walker Art Gallery, Liverpool
Ferens Art Gallery, Hull
Arnolfini Collection Trust, Bristol
University of Liverpool
Norwich City Art Gallery
Sheffield City Art Gallery
Dundee Art Gallery and Museum
National Museum of Wales, Cardiff
City Art Gallery, Leeds
Ulster Museum, Belfast
Arts Council of Northern Ireland
Scottish National Gallery of Modern Art, Edinburgh
Royal Bank of Scotland, Edinburgh
Council for National Academic Awards, UK
Gulbenkian Foundation, Lisbon
Veranneman Foundation, Holland
Museum of Modern Art, New York
Schroder Bank, New York
Chase Manhattan Bank, New York
Phillips Collection, Washington DC
Security Pacific National Bank, Los Angeles
Walker Art Gallery, Minneapolis
First Bank of Chicago, Chicago
Chicago Art Institute
Albright-Knox Art Gallery, Buffalo
Alexandria Museum, Louisiana
University of Virginia
University of Syracuse
University of Northern Iowa

Public Commissions

Robyn Denny has been commissioned to produce
site-specific work for the following:

Abbey Wood Primary School, London, 1958
Large exterior mosaic mural. GLC commissioning architects.

Austin Reed, London, 1959
Mixed-media mural. Westwood Sons & Partners
commissioning architects.

Portuguese Airways Headquarters Building, London, 1961
Mural. Verity & Beverley commissioning architects.

Paramount Cinema, Lower Regent Street, London, 1968
Giant acoustic murals. Verity & Beverley commissioning
architects.

Wills Tobacco Headquarters Building, Bristol, 1973
Banners, hangings and murals. Skidmore Owens & Merril
and YRM commissioning architects.

St Thomas' Hospital, London, 1974
Series of six large enamel panels in main entrance lobby.
YRM commissioning architects.

Church of Our Lady of Lourdes, London, 1975
Altar Reredos. Clive Broad and Partners commissioning
architects.

IBM Headquarters Building, UK, 1982
Large enamel screen in main entrance lobby.
Arup Associates commissioning architects.

London Transport – Embankment Station, 1985
Vitreous enamel panels on all platforms and intersections.
Arup Associates commissioning architects.
(This project received a Brunel Award for outstanding
visual design in 1989).

14

9 & 10
Tate Gallery exhibition, 1973

11
Exhibition at Wurttenbergischer Kunstverein
(retrospective exhibition) Stuttgart, 1973

12
Studio at Francis Wharf, London, 1974

13
Beach Avenue Studio, Venice, California, 1983

14
Studio, London, 1993

David Alan Mellor is Professor of History of Art at the
University of Sussex. He has written extensively on twentieth
century art and culture and has curated several exhibitions,
including *A Paradise Lost, New Romantic Art in Britain
1935 - 1955* in 1987, *The Sixties Art Scene London* in 1993,
and *Chemical Traces* in 1998.

Credits

The Secret Life of Art
courtesy Hirschl Contemporary Art
London
p. 11

Eckleberg
private collection, USA
p. 12

Travelling
Museum of Contemporary Art, Tehran
p. 13

From **Layline** series
(series of 14)
courtesy Hirschl Contemporary Art
London
p. 15

From **Moonshine** series
(series of 16)
courtesy Hirschl Contemporary Art
London
p. 16

From **Pepsi Tokyo** series
(series of 13)
private collection, UK
p. 17

Profile
courtesy Hirschl Contemporary Art
London
p. 19

Oh! Quel Culture
courtesy the artist
p. 21

Shadow Rising
courtesy Hirschl Contemporary Art
London
p. 22

Shadow Striding
courtesy Hirschl Contemporary Art
London
p. 25

Glory in the Air
courtesy Hirschl Contemporary Art
London
p. 28

Plaster Painting
courtesy the artist
p. 29

Mosaic (B)
courtesy the artist
p. 29

Coca Tokyo
courtesy the artist
p. 31

Footlights 2
courtesy Hirschl Contemporary Art
London
p. 33

Indiana Red
courtesy the artist
p. 34

Gothic-A-Go-Go
courtesy the artist
p. 35

Facing North
courtesy Hirschl Contemporary Art
London
p. 38

Over Here, Over There
private collection, USA
p. 39

Looking and Thinking
private collection, London
p. 41

A Sense of Occasion
private collection, London
p. 42

Frontman
private collection, London
p. 47

Home from Home
Tate, London
p. 49

Living In
courtesy the artist
p. 50

Footlights 1
courtesy Hirschl Contemporary Art
London
p. 55

World Wide 1
courtesy the artist
p. 56

World Wide 2
private collection, France
p. 57

Glass 2 From There
Scottish National Gallery of Modern
Art, Edinburgh
pp. 58-59

Travelling 2
private collection, London
p. 62

Travelling 4
private collection, London
p. 63

Sweet Nature 4
private collection, USA
p. 65

The Golden Gospel
private collection, UK
p. 66

Candy
private collection, UK
p. 71

Track 4
private collection, UK
p. 73

Ted Bentley
private collection, UK
p. 74

Transformable 1
courtesy the artist
p. 77

David Bomberg
The Mud Bath, 1914
© Tate Picture Library, 2002
p. 86

Tuscany with Palm Trees
courtesy the artist
p. 91

Windward Steam and Angel Dust
courtesy the artist
p. 92

Razzle Dazzle
courtesy the artist
p. 93

Easy
courtesy Hirschl Contemporary Art
London
p. 95

Performance
courtesy the artist
p. 96

J M W Turner
The Sun of Venice Going to Sea
exhibited 1843
© Tate Picture Library, 2002
p. 97

Sweet O'Zeeta
courtesy the artist
p. 99

My Blue Heaven
courtesy the artist
p. 100

Purple Passage
private collection, France
p. 101

Detail from a late eighteenth/
early nineteenth century Suzuribako
(writing box)
Signed by Kanyosai
© Christie's Images Ltd., 2002
p. 103

Love Wall
courtesy the artist
p. 105

Eden Come Home
private collection, UK
pp. 106-107

Hand-printed poster
courtesy the artist
p. 108

Word Row
Tate, London
p. 109

Hand-produced poster
Redfern Gallery, London
p. 111

Peter Halley
The Deep End, 2001
© the artist, courtesy Waddington
Galleries, London
p. 112

Red Beat 6
Albright-Knox Art Gallery, Buffalo
p. 113

Little Man
courtesy the artist
p. 114

Me, Myself and I (1)
courtesy Hirschl Contemporary Art
London
p. 116

Me, Myself and I (2)
courtesy Hirschl Contemporary Art
London
p. 117

Photo credits

Front cover © Rohan Van Twest
pp. 27 & 80 © Arup Associates
p. 29 © Anthony J Bisley
p. 52 © London County Council
p. 77 © Kim Lim
p. 79 © Tony Gale/Pictorial Press
p. 79 © Tony Messenger
p. 84 © Jasper Jewett
p. 87 © John Donat
pp. 89 & 90 © Doreen Nelson

Colophon

Copyright © 2002
Black Dog Publishing Limited and the authors and artists.
All rights reserved.

Black Dog Publishing Ltd
5 Ravenscroft Street
London E2 7SH
UK

T +44 (0)20 7613 1922
F +44 (0)20 7613 1944
E info@bdp.demon.co.uk

Hirschl Contemporary Art
5 Cork Street
London W1S 3LQ
UK

T +44 (0)20 7495 2565
F +44 (0)20 7495 7535
E hirschl@dircon.co.uk

Designed by Studio AS.
Printed in the European Union.

ISBN 1 901033 33 3

■■■

Architecture Art Design
Fashion History Photography
Theory and Things

Hirschl Contemporary Art